Borja Gonzáles

Photo Tales 2

Wildlife Photo Stories from Africa

Compiled by the Van den Bergs
& Ronél Bouwer

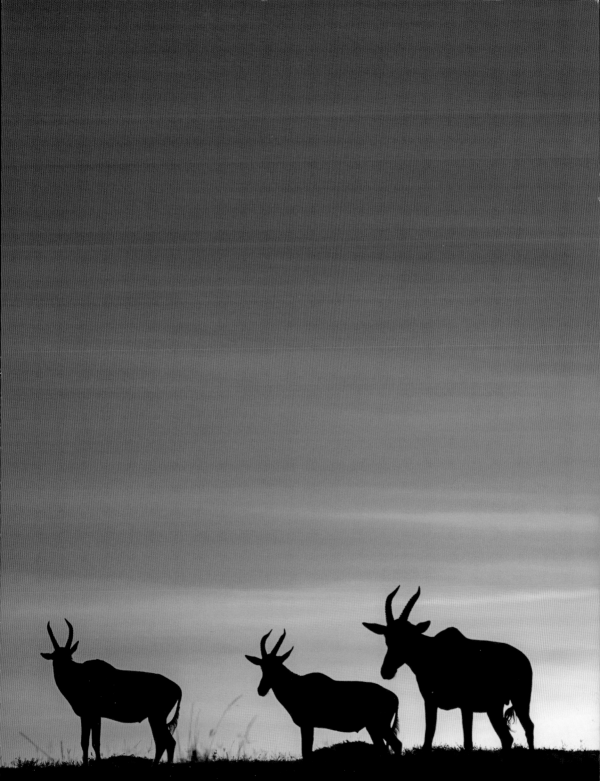

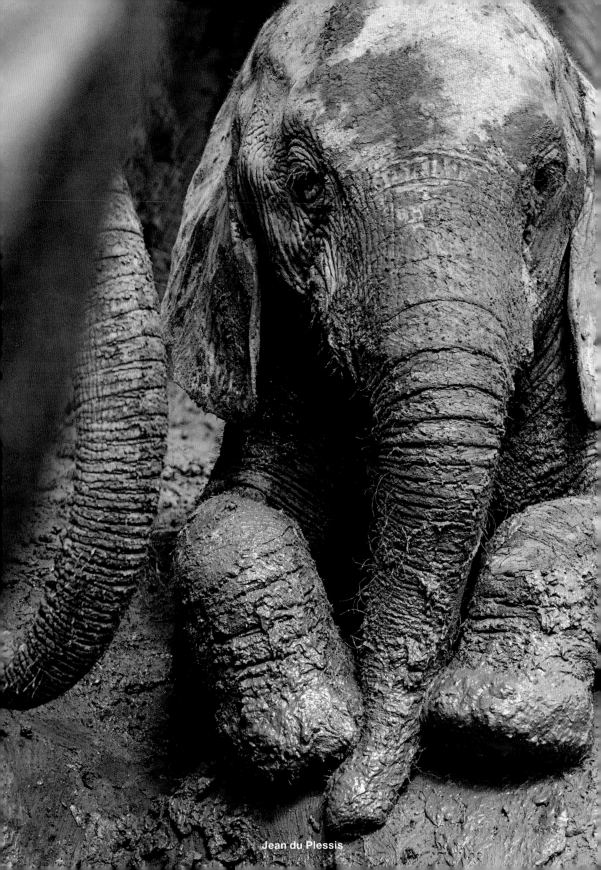

Jean du Plessis

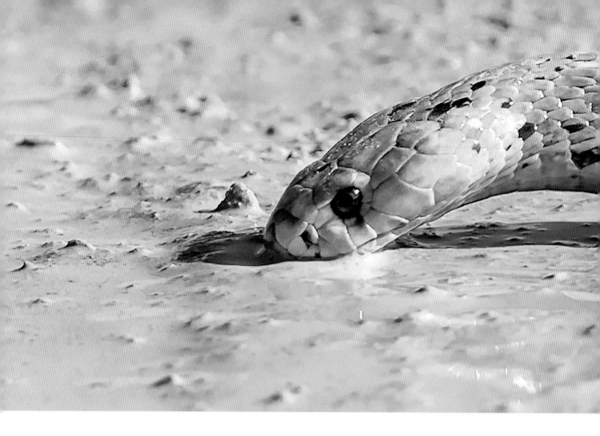

Contents

Andries Janse van Rensburg

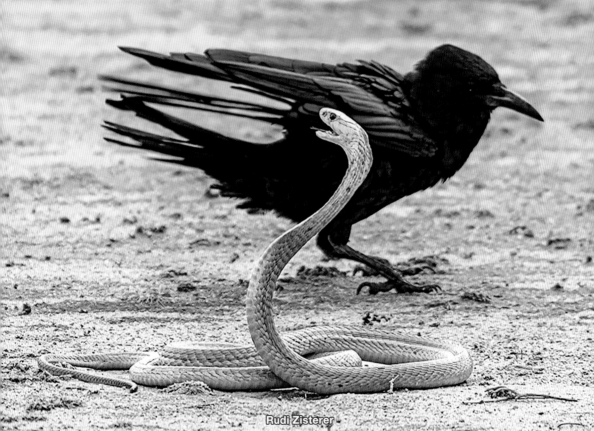

Rudi Zisterer

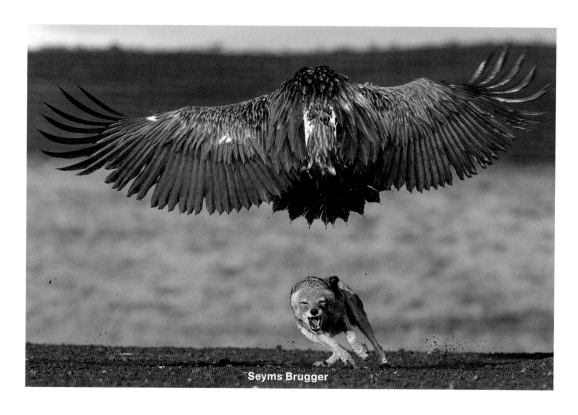

Seyms Brugger

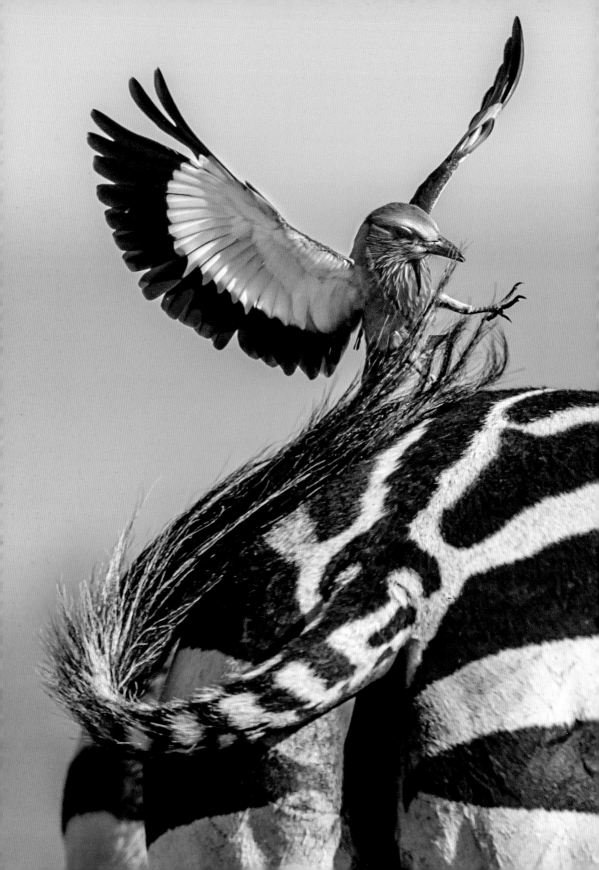

Eduardo Del Álamo

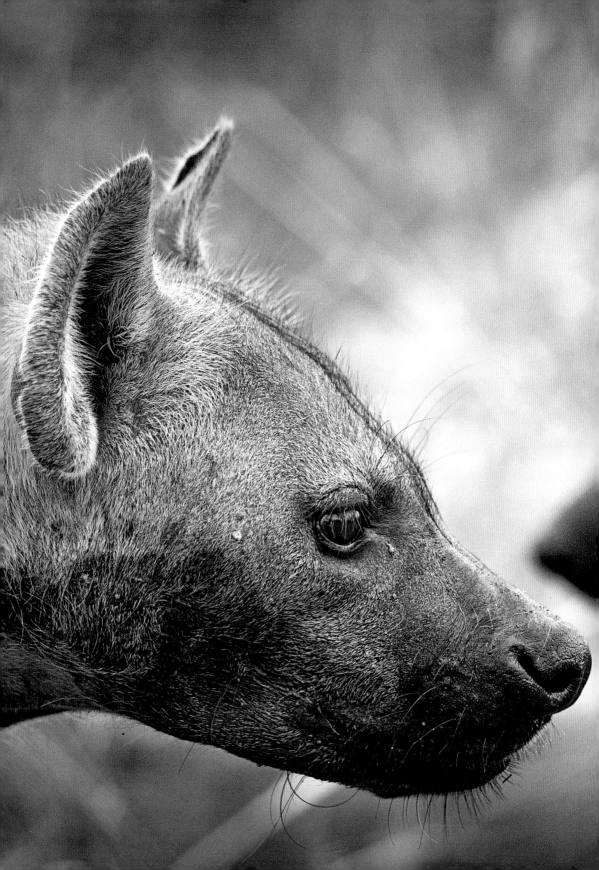

Armand Grobler

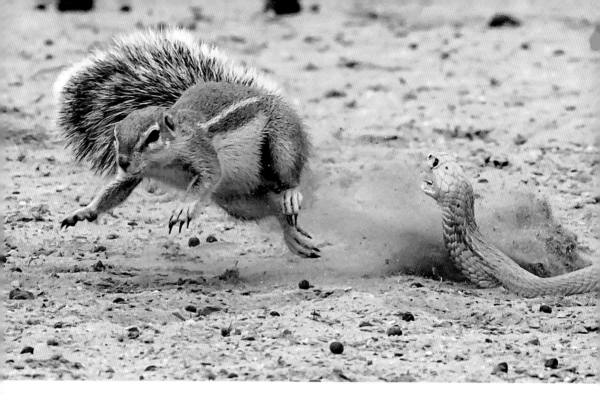

A Brave Defence

BOMBER KENT

We were in the Kgalagadi in December 2019 and driving near Urikaruus when we saw a vehicle parked on the side of the road. It seemed that a ground squirrel was the attraction. But as we got closer, we saw a cobra, too. We judged the ground squirrel to be a mother with babies because of her prominent teats. She was attacking the cobra: probably trying to prevent it from going down her hole where, no doubt, her babies were sheltering. This went on for at least half an hour until the cobra eventually went down the squirrel hole. We reckoned this was a rather special sighting and we were delighted to get some great images.

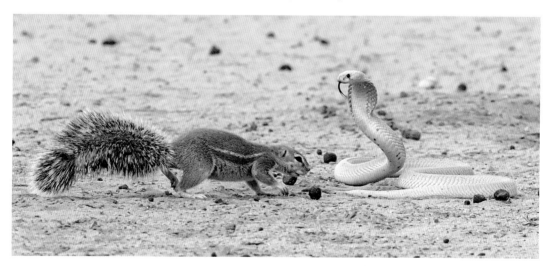

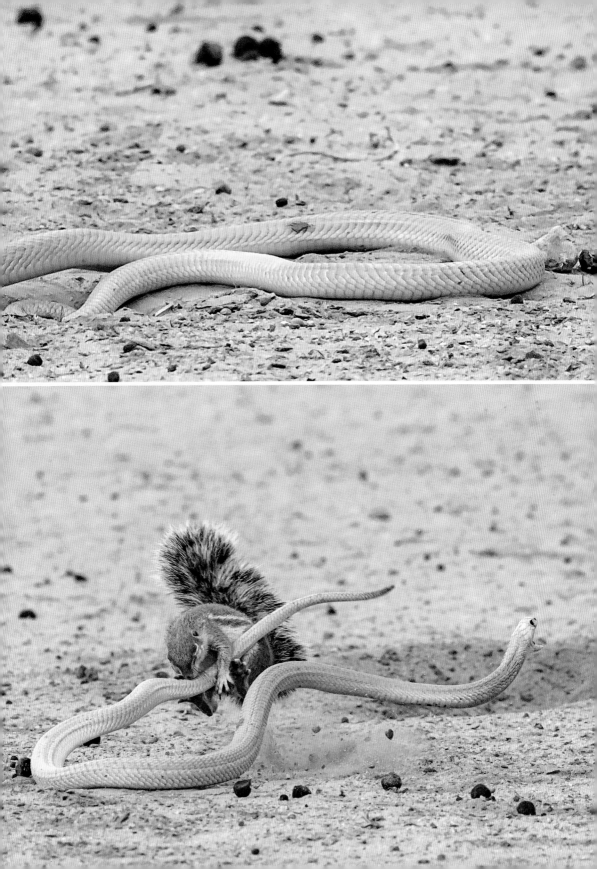

Fight for Life

KOOS FOURIE

Travelling in the Kruger National Park between Skukuza and Lower Sabi on the Salitje Road, we saw three burly warthogs trotting in the bleak, dusty road ahead of us. I brought my vehicle to a quick halt, parking sideways in the road, with my ever-ready camera set on high-speed continuous shooting, braced and ready for action. I opened the window hurriedly, my eyes fixed on the biggest warthog. As I pushed the camera's shutter down, I became aware of a noise nearby. My initial thought was that the piglets belonging to the warthogs were just having fun frolicking around. I was so wrong...

The quiet, serene scene abruptly changed as a leopard emerged out of nowhere, ambushing one of the petrified piglets. In a cloud of dust and confusion, carnivorous fangs sank into the piglet's neck. Two of the warthogs barrelled away past my car in panic. The piglet was kicking fiercely as it tried to escape the deadly incisors of the menacing leopard, its desperate squeals resounding over the dusty surroundings.

Frantic to save her baby, the mother turned and came charging fiercely and at full speed from behind my vehicle. Dropping her head threateningly, she bravely head-butted the un-suspecting leopard in the ribcage. She retreated quickly and then turned on the disoriented and stunned leopard again. The second wallop resulted in the leopard losing its grip, sending the piglet swooping through the air. The outraged mother charged after the leopard, chasing it into a culvert next to the road. This gave her the opportunity to escape with her youngsters, leaving behind a dismayed leopard, denied a sumptuous meal. Moments later I could hear the leopard snarl dejectedly as it sloped past my vehicle, as if to express its annoyance to me.

Releasing my breath slowly, I realised that the incident was so brief, it was all over in a single minute. I was exceptionally grateful that my trustworthy camera had archived this incredible and fascinating experience. By the time the next vehicle came by, the dust and excitement had settled, leaving absolutely no trace of the jaw-dropping event that had played itself out just moments before.

Warthog is a tasty treat on any leopard's menu but this time the adrenaline and protective instincts of a vigilant mother, prepared to compromise her own life in order to protect her baby, saved the young warthog's chops!

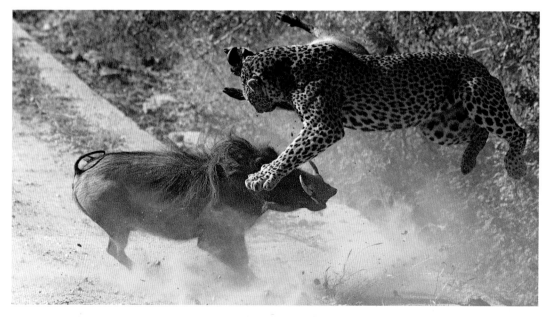

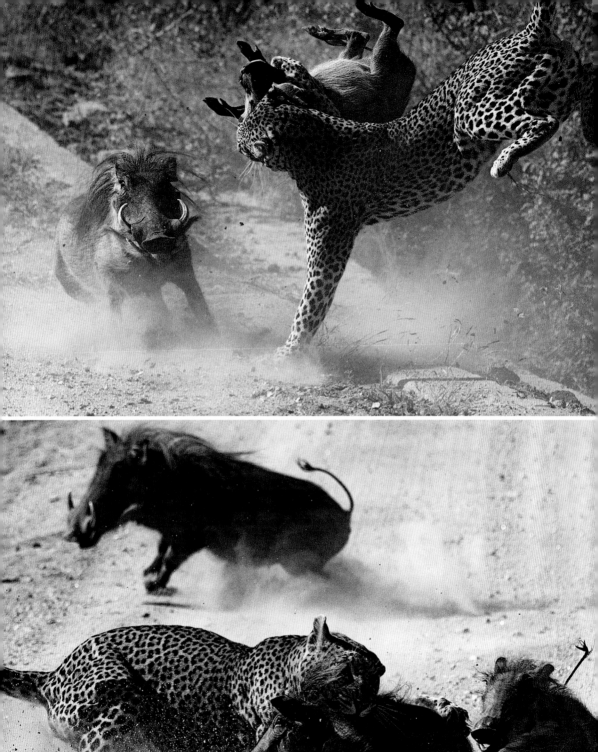
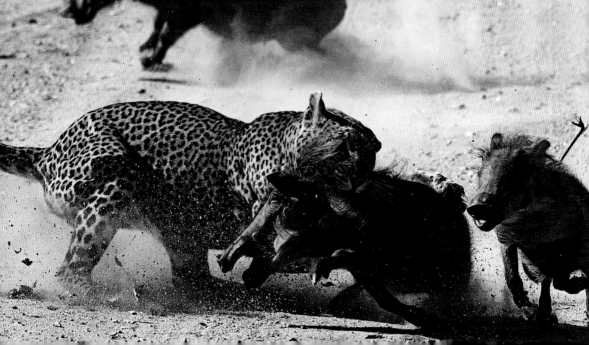

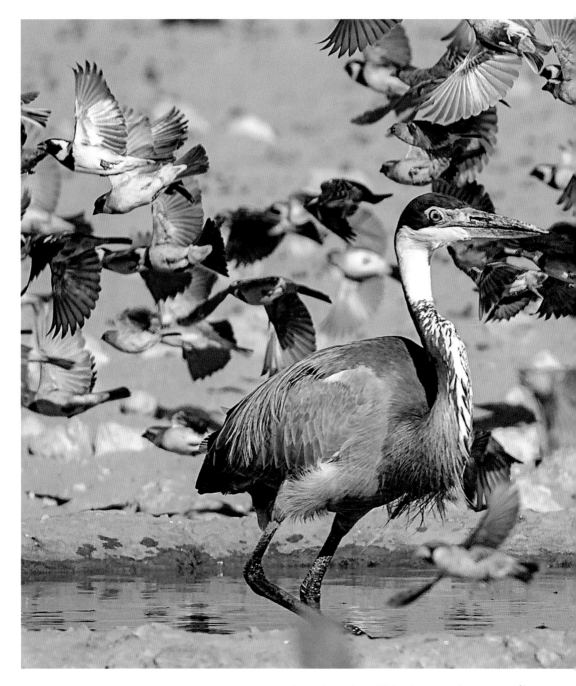

Innovation is the Name of the Game

EDMUND AYLMER

Whenever I visit the Kgalagadi Transfrontier Park, I always try and stay at Twee Rivieren Camp for at least four days. This gives me the opportunity to travel the Nossob River Road and spend time at the waterholes between the camp and KijKij Waterhole. This route has never failed to provide me with incredible photographic opportunities.

On this particular occasion, I was waiting at the Leeuwdril Waterhole where hundreds of Cape

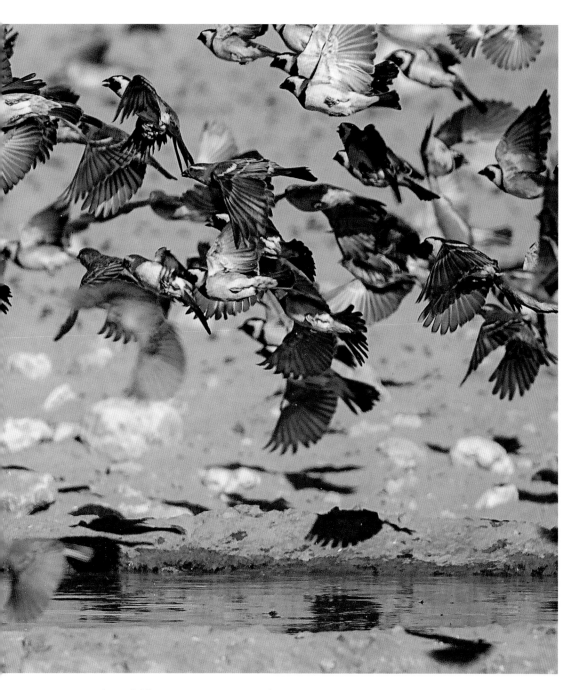

sparrows and sociable weavers were coming down to the water. I saw a black-headed heron flying into a nearby tree, watch the mass of birds coming in to drink and then fly away again at the slightest sign of danger.

After a while, the heron flew down to the waterhole and I watched in amazement as it scattered the mass of drinking birds. It slowly waded through the water, lunging at the birds that were slow to fly off. I had the privilege of photographing all the action from selection of the prey through to the final capture. We generally associate herons with catching fish and frogs, so to see one trying to catch small birds was a special experience.

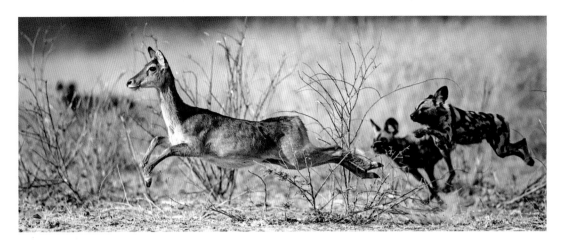

It's Not Only Princesses Who Have to Face Obstacles

LOUIS TALJAARD, ANTON GEYSER & ISAK PRETORIUS

We, a small group of photographers and aspiring photographers, were visiting Bilimungwe Bushcamp in Zambia's South Luangwa National Park. During an early morning game drive, we witnessed an incredible series of events with a young female puku as the heroine of the story.

The puku, a common antelope in the park, is similar in size to the impala, with longer brown hair which gives its coat a fluffy appearance.

We had spotted a pack of wild dogs, resting and playing, in a dry floodplain one evening and were fortunate to catch up with them during the early morning drive the next day. We found the dogs out on the hunt on a large plain with a few trees and sparse brush vegetation. A small number of antelope could be seen grazing in the distance.

The dogs spotted a solitary young female puku and started the chase. With the dogs running at full speed in pursuit of the fleeing buck

and with the puku making spectacular jumps to clear the low growing vegetation in her path, the excitement of the onlookers was palpable. The dogs were gaining on their prey and had almost caught up with her when she reached the edge of the Luangwa riverbank. The bank on that side of the river was at least six metres above the water level. Without reducing speed, the puku leapt into the water flowing far below. The dogs stopped at the river bank and could only watch in disbelief as their prey swam out of reach in the river below. After a moment the dogs turned back to pursue other opportunities, as they couldn't manage the descent.

We arrived at the riverbank and, in astonishment, watched the unfolding drama below. At that position the river was probably 100 to 150 metres wide and the puku was swimming in a direction roughly parallel to the bank. A smallish crocodile

was heading straight towards the buck. As the crocodile caught up and attacked her from the rear, we saw the jerk of her body as she lifted her head and neck out of the water. She was held back and tugged underwater from time to time. The puku fought gallantly and continued to swim towards a break in the riverbank some five to 10 metres away. A large crocodile arrived on the scene and the young crocodile, probably in fear of becoming breakfast, let go of the prey and disappeared underwater. The big croc moved in but the puku secured its footing on the river bed and scrambled out of the water at the break in the wall, just before the crocodile could get hold of her.

At no other spot along the river's edge, as far as we could see, could she have got out of the water than at the break in the bank where she was now standing. It seemed miraculous that she had found it. She stood on a small ridge, a third of the way up the bank, recovering her breath and wits, perhaps reliving the ordeals she had faced.

An hour later we drove past the spot and saw her standing under a tree on the floodplain close to the spot where she had climbed up the break in the wall. She looked a bit forlorn and was constantly licking what must have been the wounds administered by the crocodile to her buttock. There was no visible sign of blood and it appeared that the damage was limited to bite wounds – fortunately in a place where she could lick them clean.

As we left, we wondered if the wounds might fester and whether she would succumb to other predators in the coming days, though we all sincerely hoped she would survive to tell her offspring the story of escaping the wild dog onslaught, surviving the suicidal dive, outmanoeuvring the crocodiles in the river, and finding the only spot in the impenetrable riverbank to exit. She'd had a truly remarkable escape from ace predators, and deserved to be the protagonist in a fairy tale.

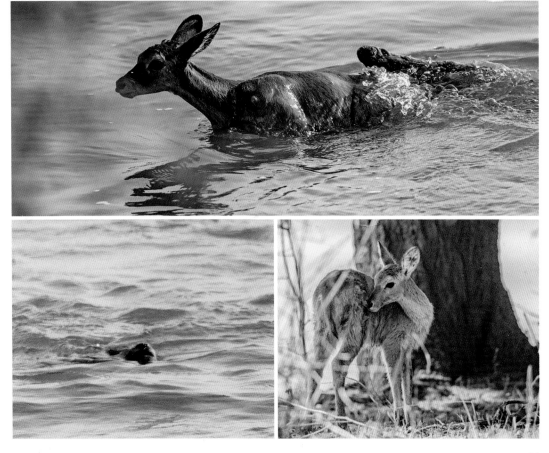

The Day the Honey Badger's Reputation Took a Big Dent

MOHAMMED & SHARIFA JINNAH

Many dramatic events play out in the bush every day and sometimes we are fortunate to witness such an event. In November 2014, we got to see an astonishing interaction between a honey badger and a Cape fox pair.

It was the last day of our trip and we were staying at Urikaruus Camp in the Kgalagadi Transfrontier Park. We left camp at first light and made our way towards the Twee Rivieren Gate. It was a quiet morning so when we got to Samevloeiing Waterhole, which is five kilometres from Twee Rivieren, we decided to drive to Leeuwdril Waterhole on the Nossob side of the park. We knew three cheetahs were in the area as they had killed a red hartebeest the day before.

We found the cheetahs, but they were not particularly active, having eaten their fill. Black-backed jackals were feeding on the hartebeest carcass. We took a few photos and made our way to Twee Rivieren. About a kilometre south of Leeuwdril Waterhole we heard the most distressing shrieks from behind a bush but could not see what was going on.

I stopped and then we saw a honey badger being chased by a Cape fox with another Cape fox looking on. An ever-opportunistic black-backed jackal was standing in the background. It took us a while to register that the honey badger was trying to dig out a Cape fox cub from the den and the parents were protecting their young. We thought this could only end one way. The honey badger is all muscle and claw, fearless and willing to take on any animal that gets in its way. By comparison, the Cape fox is a timid animal that one usually sees sitting at the entrance of its den.

The badger was moving from one den entrance to the next, digging furiously. The Cape foxes were barking and working as a team. One would nip the badger from the rear and when the badger turned, the fox would flee and the other one would then be at the heels of the badger. All the time the jackal was looking on, hoping something would come its way.

One Cape fox cub lost its nerve, came out of one entrance and bolted down the other. Another cub fled down the road, fortunately not seen by the jackal or the honey badger.

It went on like this for 10 minutes until the honey badger was completely frustrated and was seen off by the Cape foxes. He looked our way as if to say, "What are you laughing at?" He left with his tail between his legs and his ego dented.

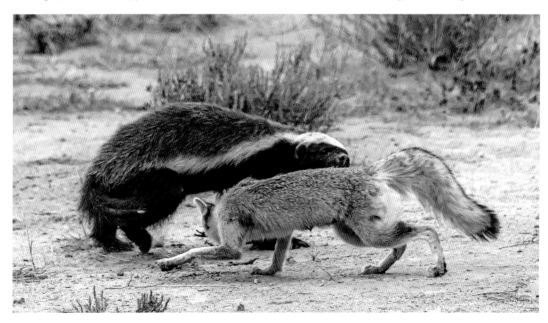

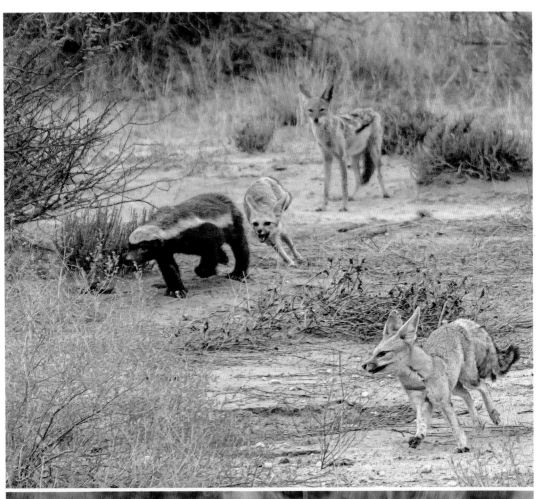

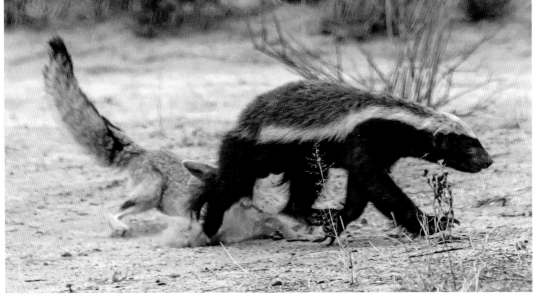

A Strange Quirk

KURT SCHULTZ

One Saturday morning, I entered Kruger very early as I had a breakfast appointment at Skukuza. I'd been running *Kurt Safari* for the last 10 years, so I spend most of the week in an office. Weekends are my time to get into the bush with my camera, but I hadn't had a lot of luck lately.

I went to an area where there'd been some recent lion sightings and came upon a troop of baboons who were really excited and playful, as they often are early in the morning. Someone in another vehicle said they'd seen a lion cub among the baboons. This area has large granite hills and boulders on it, and lions and leopard are known to hide their newborn cubs in this region.

After a while we spotted what appeared to be a female baboon carrying a dead lion cub.

The baboon crossed the road and climbed a marula tree. We realised then the lion cub was alive and the baboon was male. The baboon was grooming the lion cub as if it was a baby baboon. While it is true that male baboons do a lot of grooming, the care given to this lion cub was like that of a female baboon to one of her own.

The rest of the troop got used to the presence of the lion cub and the group settled, with the male baboon moving from branch to branch, grooming and carrying the cub for a long period of time. The cub seemed dazed, though we could see no external injuries. However, baboons are strong and vigorous in their movements, and in the rough-and-tumble of the troop handling the

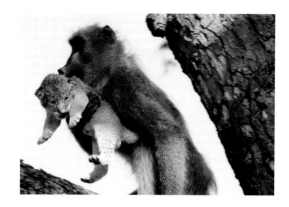

baby earlier, the lion cub could have sustained internal injuries. It was 8:00 in the morning and already the temperature had reached 30 degrees, so the cub was probably becoming dehydrated. The baboons moved further in and I left the sighting as other vehicles began arriving.

In 20 years of guiding in southern and east Africa, and in the Kruger for close on 20 years, I have witnessed baboons viciously killing leopard cubs and have heard of them killing lion cubs but I have never seen care and attention given to a lion cub in this manner before, particularly by a male baboon.

I knew this poor cub couldn't survive: the troop of baboons was too large for its mother to attempt to rescue it. Nature is often heartless and the survival-rate of young predator cubs is, as we know, low at the best of times. Furthermore, a grown lion poses a threat to the baboons in turn.

Nobody caught sight of either the baboons or the lion cub again, but it was the rainy season, the vegetation was thick and the baboons could easily disappear from sight.

This was one of the most interesting sightings I have ever had and highlighted the question of how far we as humans are allowed to intervene. Although we might all wish that the cub would survive, it is not for us to meddle in the interactions of the animals.

Guides and park rangers all know that it is not their place to interfere when nature is following its own path. The Kruger (and other reserves) are places where nature's course must be allowed to run: simple and wild, the way Stevenson-Hamilton wished.

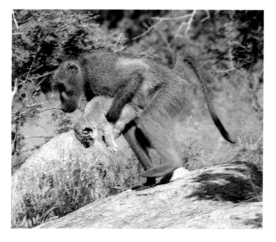

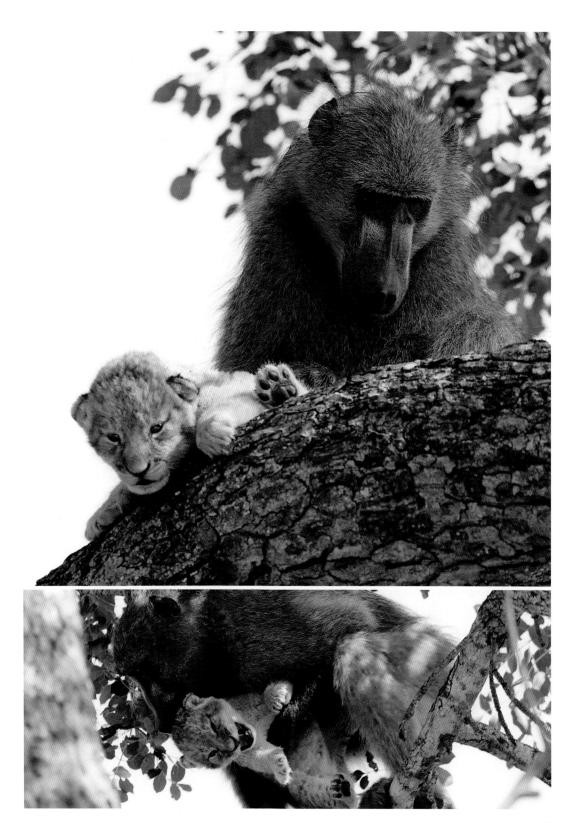

The Lion and the Baby Steenbok

GRAEME MITCHLEY

This sighting was probably our most heart-wrenching. My wife, Angela, and I are well aware that nature follows its own laws and events in the wild take their own path, but sometimes they are extremely difficult to witness. My wife couldn't bear to watch this particular one. My adrenaline was pumping so it didn't affect me at the time, but when I watched the video later I was almost brought to tears.

It was late December 2016 and we were heading to Lower Sabie from Satara. It was at the height of the drought and both Kumana and Mazithi Dams were bone dry. It was hot and dusty and to make matters worse, the wind was blowing. There was dust everywhere. Little did we know this wind would bring heavy rain and the end of the drought.

As we passed Mazithi Dam, I reminded Angela I had seen two lionesses, one big male and six cubs on a buffalo kill there in July 2016. I wondered where predators went in these harsh times.

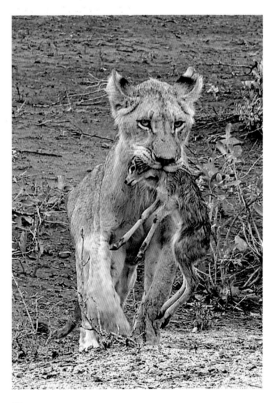

Where do they find water? Where do they find prey? There was certainly not an animal to be seen at this point. But just past the dam there were a few vultures and marabou storks on the right-hand side, evidence that a kill had recently taken place. So there were predators there after all.

Out of the corner of my left eye, I saw an animal walking out of the desolate surroundings towards the road with something in its mouth. At first I thought it was a lioness with a cub in her mouth. Then I realised it was a young lion with a newborn steenbok. He was carrying it gently, just like a mother would carry a cub. He crossed the road and lay down next to the car. The little steenbok was bleating – a most distressing sound. The young lion looked extremely proud of himself but didn't know exactly what to do with his prize. He must have stumbled upon the newborn by accident while walking through the bush. I was hoping he would put the poor thing out of its misery because the bleating was unbearable. The little steenbok tried to move away but each time the lion put a paw on it. The lion even started removing fur from the youngster. I have seen predators do this in the past before eating their prey.

The vultures ventured closer, which made the young lion nervous. He decided to head down to the dry riverbed with his booty. Even when he was out of view we could still hear the bleating. Being inexperienced, the lion wasn't quite sure how to dispatch of his prey. There is no doubt that the bleating would have attracted hyenas or other pride members. Some people have asked if the lion was protecting the steenbok but it was impossible for a happy ending to unfold.

This was definitely a case of right time, right place! That's the thing about nature and the Kruger Park, you just never know what is around the next corner. It is what keeps me going back time and again. Even on a quiet day, just being in the bush is enough for me, finding a quiet road, switching off my busy thoughts, listening to the sounds the bush has to offer; it is the place where I get to unwind, to de-stress and just breathe!

A Prickly Situation

GRAEME MITCHLEY

While I was waiting at Crocodile Bridge Gate in the Kruger Park early one Friday morning, I overheard the honorary ranger telling another visitor that a leopard had killed a porcupine the day before on the H10 near the S32 Orpen Dam Road. As that's quite some distance from Crocodile Bridge I decided not to go straight up there.

I had a great morning on the S28 before going towards Lower Sabie and then heading to the H4-1 and S79, a well-known road for leopard and lion. I saw two prides of lions with cubs and herds of elephants coming down to the water. At Sunset Dam I sat for an hour watching a baby hippo, crocs and lots of different bird species. Later, I decided to head up my favourite road in the park, the H10. I just love this road, not only for the abundant wildlife, but the peace and quiet and the open plains. Heading up to see the leopard didn't even cross my mind. He would hardly still be around after making a kill the day before.

But he was. At 11:45 I arrived at the leopard sighting. There were a lot of cars. Someone pointed out the leopard: he was lying in thick grass behind dead branches. I could see his tail flick and his ear twitch. His kill was now in a very flim-

sy tree. I decided to wait it out. Lots of people came and went because it was hot and people got bored. I spent four hours at this sighting. For three of them, all I could see was an ear and a tail. Every now and then the leopard rolled over and stretched. The tree with the kill was close to the road so I didn't think he would emerge. There were too many cars and too much noise.

However, lo and behold, after three hours, Mr Porcupine Slayer came out and put on a display I will never forget. He walked straight towards me and over to the kill, then jumped up and began to eat. It was obvious that eating a porcupine is no easy matter. Every bite came with a quill. The meat must be worth the inconvenience, I reckoned.

After about 20 minutes, two hyenas came along, forcing the leopard even higher into the tree and actually on top of his kill, which must have been even more uncomfortable. He growled at them but was more focused on eating. There was no way he was sharing! The poor hyenas only received a few quill darts aimed in their direction. I laughed as the hyenas, like me, decided to wait it out.

After photographing and filming this scene for close to an hour, it was time for me to head back to camp. Unfortunately, I didn't see how the scene played out but I had been given the show of a lifetime. The leopard gods were certainly on my side that day.

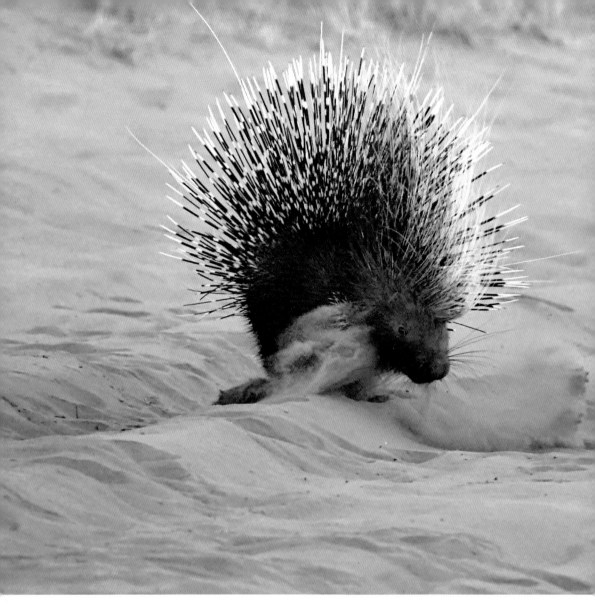

Spots and Spikes

YVAN FRANCEY

As always, I was at the gate of Nxai Pan National Park early that July morning. Driving alone, before sunrise, on the sandy track leading to the pan, I was intrigued by a black spot on the road in the distance. Much to my surprise, I realised it was a porcupine standing in the middle of the sandy track. I edged forward because it is a shy animal, difficult to photograph and a relatively rare sighting at Nxai Pan. But to my surprise, it stayed put and didn't seek refuge in the nearby

bush. I took a few photos and noticed that there were a lot of tracks around it. My analysis was that the porcupine had been chased by a predator and was still in a self-defence position in the middle of the road. From there it had a clear view and could deal with any attacker by presenting it with the sharp thorns of its spiky back and its club-shaped tail. When taking more photos, I tried to get a low-angle shot from my car window with my telephoto lens.

Then incredibly, in my viewfinder just behind the porcupine, appeared a leopard from the bush, stalking the porcupine by the roadside! My heart jumped… It was difficult to remain calm, to simply

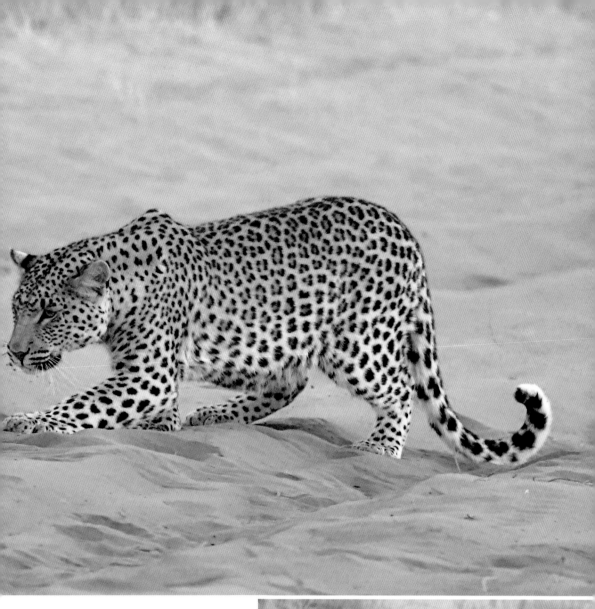

look at the scene and take some more pictures (yes, but which framing, which shutter speed?). After a while, and two or three circuits, the leopard comprehended it would not be getting a free meal that day. Taking one last look at this strange and perfectly protected creature, it padded along the sandy track and disappeared into the bush, with a flock of birds raising the alarm. The gladiator was still proudly standing in the arena, knowing it could challenge any opponent there. What a great example of self-defence for survival!

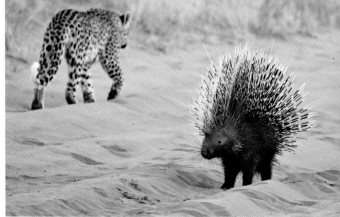

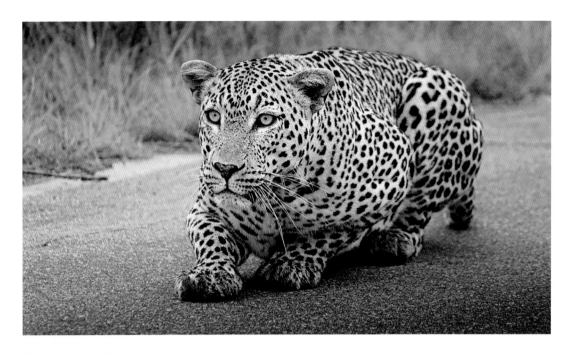

Predator Rivalry

THOKOZANI PHAKATHI

December 2019
There I was on the H1-1 main road just east of Pretoriuskop during one of my Kruger National Park excursions, when I spotted a big male leopard moving eastwards, patrolling and scent-marking his territory.

Coincidently, a male cheetah was in the same vicinity, but heading in a westerly direction. He, too, was scent-marking the area. However, he seemed to be in some distress, as he was calling frantically. Maybe he was calling an absent family member or had been pushed out of a coalition.

When he became aware of the cheetah, the leopard immediately began stalking him, padding with extra care and then settling into a crouch. Using a tree trunk as a screen, he positioned himself at the spot where the cheetah would pass. The unsuspecting cheetah was effectively walking into an ambush, masterminded by a predator of superior strength. It was a moment both exciting and horrifying... how was this going to pan out?

I didn't believe this would end well for the cheetah – how could it? – but I knew nature remains true to itself. In line with its instinct, a predator must kill when it can. And predators are always in competition for food, space and other natural resources.

When the cheetah was a couple of metres away, the leopard sprang out. The cheetah momentarily drew back in shock but then instantly put on all speed and ran for his life.

There was a moment when the length of the cheetah's tail was all that separated the two cats, but the fastest mammal on land is not called that for nothing. He sped away and, astonishingly, he was uninjured. He had evaded an almost certain death by leaving the heavier, more powerful predator behind.

After the attack and chase, which lasted less than half a minute, the cheetah was in a state of shock, shaking and jumping in terror whenever a branch brushed his limbs or tail.

Never will I forget this encounter; to watch the actions of these two remarkable predators and to have captured it all on camera, too, was a privilege I will always be thankful for. It is moments such as these that make the Kruger National Park so special. No wonder people call it a paradise on Earth, one that holds both the beauty of Africa and the marvel of its diverse wildlife.

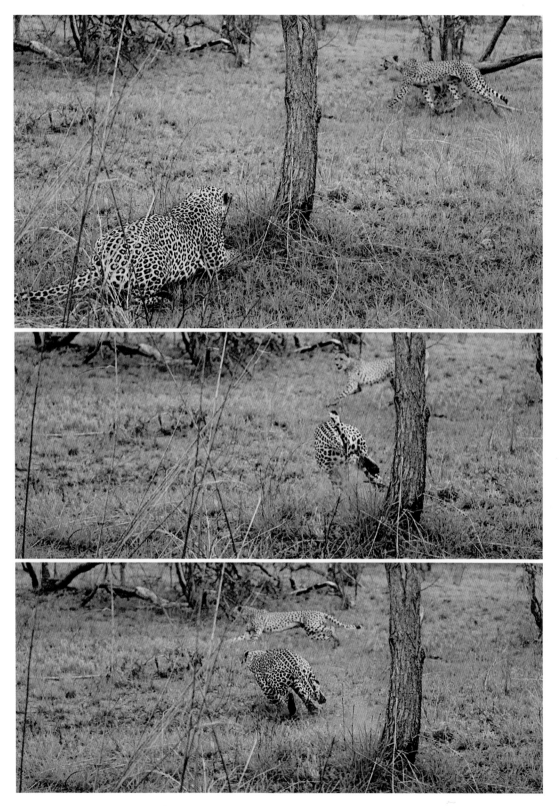

Two Felines – One Winner

WILLIE & GERDA VAN SCHALKWYK

Early one overcast morning while driving north towards Thirteenth and Fourteenth Borehole in the Kgalagadi Transfrontier Park, a movement caught our eye. It was a female leopard moving in the distance on the far side of the Auob riverbed.

The leopard is the least frequently seen of the Kalahari's large cats and, of course, any sighting is special. So, it was with great excitement and expectation that we slowly made our way along the road, following her as she moved about in a leisurely way, criss-crossing the dry Auob riverbed. All of a sudden she began chasing something across the riverbed towards us: an African wild cat! The cat outran her but from our point of view this had the advantage of bringing her closer and onto our side of the riverbed. She continued her search across the breadth of the riverbed, stopping to spray-mark from time to time.

We watched as she went up a camelthorn tree, and then there was a flurry of activity and a thud. She had caught an African wild cat (the same one or another one – we couldn't tell) high up in the tree and tumbled down with it.

She subdued the cat and suffocated it, then walked away and lay down briefly to recover. She had a fresh scratch on her left check; the African wild cat had fought bravely to the end. After resting a while, she returned to her kill and started playing with it in true cat style and then moved it out of view. We stayed with her as she walked about and then settled behind a tree, hidden from view.

After a while, a jackal moved in too close for her comfort, and when its barking and pressurising of her became too much, she appeared again with her prey and carried it across the road up the dune on the opposite side of the riverbed.

We were disturbed by this sighting but learnt African wild cats often feature on the menu of Kalahari leopards. One of the reasons for leopards' success is the variety of prey they consume and in the arid Kalahari this can range from tiny mice to adult hartebeest.

Using the Kgalagadi Leopard Project's information, we later identified this leopard as Itumeleng: a female, two years old at the time of the sighting in 2016.

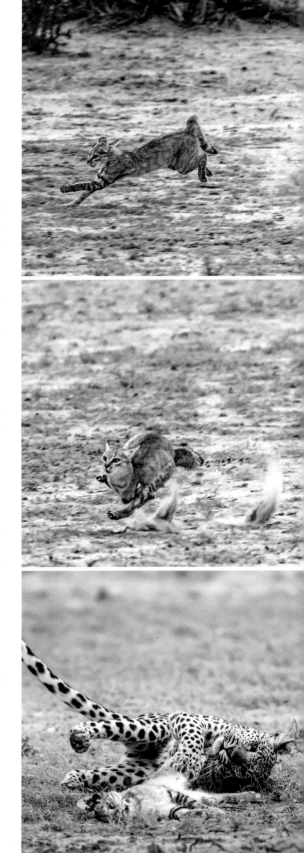

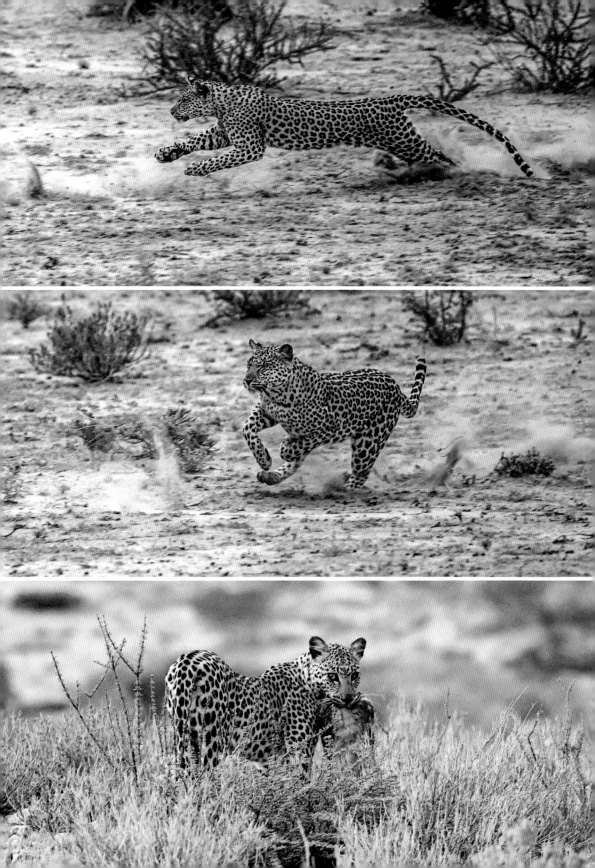

The Flying Cat

MOHAMMED & SHARIFA JINNAH

In August 2013, we were staying at Kalahari Tented Camp in the Kgalagadi Transfrontier Park. It was the last of our 12 days in the park. This was the first time we'd come in winter and it had been a quiet trip compared to the visits we'd had in the spring and summer months.

We decided on a long afternoon drive to Fourteenth Borehole and back. We saw four cheetahs at Sitzas Waterhole, but they were some distance from the road, which didn't make for good photography.

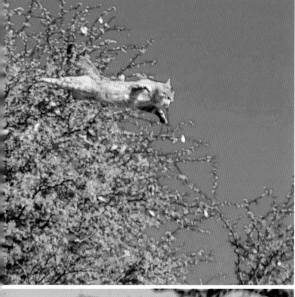

We found ourselves at a quiet Fourteenth Borehole at 16:30 so started making our way back to camp. At the top end of the loop road Sharifa suddenly said, "Stop! Leopard." The female leopard was in the shade of a tree and so well camouflaged that at first I couldn't spot her. Leopards thrill me and this was only our second one on the trip.

She walked out into the open and then stopped at a tree, caught something, possibly a tree rat, and gulped it down. She did some territorial spraying and continued walking. In the hopes that this might be Tsamma, Sharifa said, "Hello Tsamma, come to Mama."

It was as if the leopard understood because she started walking towards us. She crossed the road in front of us but then stopped, as if to say, "Come along, come along." She sniffed in the bushes and flushed out an African wildcat. I said to Sharifa, "Wildcat coming your way, be ready to snap it." And then, "Leopard coming your way."

The African wildcat ran up a camelthorn tree that we estimated to be about 12 metres high. The leopard we confirmed to be Tsamma followed but stopped to look at us, providing us with some great poses. She seemed to be asking, "Shall we do this?" "Yes, let's do it," we breathed.

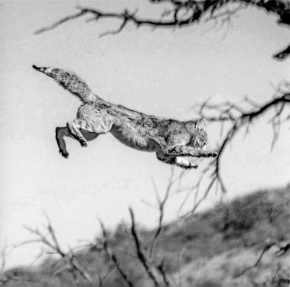

Tsamma jumped from the branch she was posing on to the main branch of the tree. She inched her way towards the wildcat. We thought the cat was safe as the branches would be too thin for Tsamma. But slowly and deliberately she climbed up. The wildcat lost its nerve and jumped. It was too quick and too agile for Tsamma and got away. It has another eight lives.

No Mercy in the Bush

CISZANNE CROUS

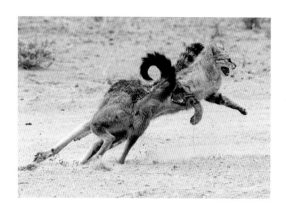

During our visit to the Kgalagadi Transfrontier Park, we had a once-in-a-lifetime experience on a very hot summer's day in December 2018. We were on our way back to Rooiputs Campsite as it was blazing hot, close to 45°C. In the distance there was a cloud of dust and we were curious as to what might have caused it.

As we got closer we saw a black-backed jackal and an African wild cat attacking each other. We assumed it was a territorial battle, but soon realised this was not the case when the black-backed jackal succeeded in killing the African wild cat. The jackal then proceeded to eat its prey.

We were taken aback at what we had seen and found it hard to believe two carnivores would attack each other and that the victor would actually consume the loser. Nature follows her own rules…

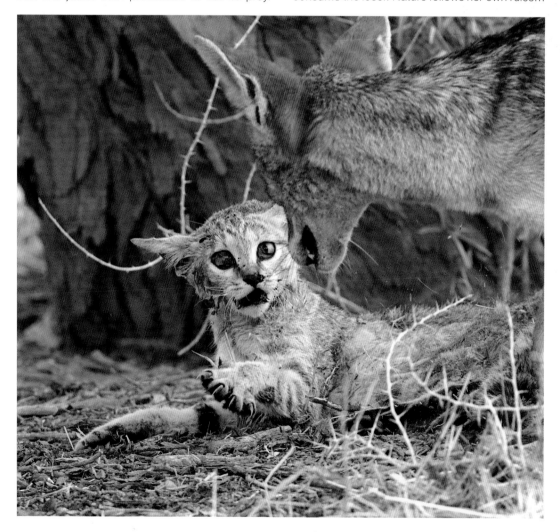

Trapped in the Mud

DAVE WOOLLACOTT

The scene in the riverbed of the Shingwedzi River was serene, with water sparse and shallow due to the prolonged drought. Elephant drank and then lumbered up the river bank, stopping to chase off a lone buffalo that wanted to tag along.

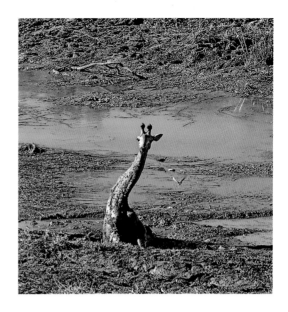

As we watched, there was movement in the mud. This was about 90 metres from us so even with binoculars it wasn't clear what had moved. Intrigued, we waited. Slowly the head of a giraffe emerged and writhed around, reminiscent of drawings of the Loch Ness monster. It seemed inconceivable that the body of a giraffe could be buried in what appeared to be shallow mud! A crocodile was well positioned to take advantage of the situation.

An older giraffe (the parent, perhaps) returned to the scene frequently but could only look on help-lessly. The stricken animal thrashed about and tried to free itself but kept collapsing in exhaustion. Had it broken a leg? Or was a crocodile hanging onto it in some way? To make things worse, there was a hyena den a mere kilometre away.

Word got back to camp and three Kruger Park rangers arrived and tried to help the giraffe to stand. But they were unable to put a rope around the animal and were at risk themselves from the flailing legs and neck, so the task seemed im-possible. They were joined by 10 onlookers with ropes and branches.

Finally! To much applause from the cars that had gathered, the weary animal stumbled onto dry land, only to fall back again towards the mud. Minutes later, another heave and the giraffe was on its feet again. People left the scene, hoping the giraffe would manage the rest.

The young giraffe was obviously well aware it was in danger from predators that would now as-sume it was weak and exhausted. But two hours after our first sighting, he galloped elegantly into the setting sun. At the top of the river bank he stopped and, in a poignant moment, looked back as if in thanks at the park rangers and helpers. Then he melted into the mopane bushveld.

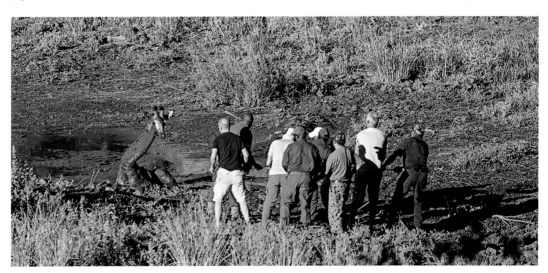

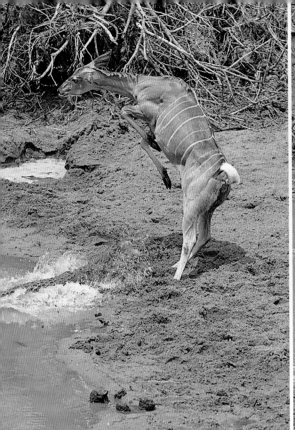
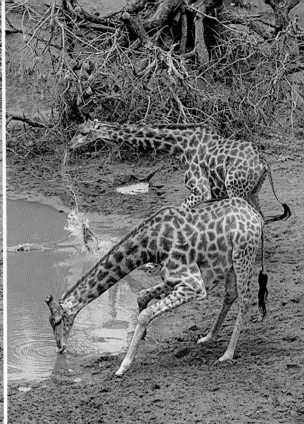

Some Days You Just Have No Luck

MATTHEW SCHURCH

The Hluhluwe-iMfolozi Park in KwaZulu-Natal was suffering terribly due to drought and, apart from a few pools, the riverbeds were dry. After a morning of slow sightings we decided to stop at the Mphafa Hide on our way back to camp. We knew we would find water there.

As we walked down the long entrance passage, someone told us that we'd be able to see both a crocodile and some giraffes. We quickened our pace so as not to miss the excitement. And sure enough: there was a group of giraffes drinking from the water's edge and within a few minutes a commotion ensued. A crocodile snapped at the head of one of the giraffes.

The giraffe reacted quickly and raised its head clear of the lunging crocodile. Of course, the event caused panic among the other giraffes and they all left quite smartly.

It was quite clear the crocodile was outmatched: it was hunting way out of its league with an animal the size of a giraffe. We settled down and waited to see if any suitably sized prey would arrive. About an hour later a lone female kudu gingerly made her way to the water, straight into danger's way. I readied myself and my camera for what was to come.

She drank for about two minutes, looked up, relaxed and settled down for more. The tension in the hide was high. A shadowy shape appeared in the greenish water right in front of the kudu. We held our breath. A rush, a huge splash, and the croc very nearly had its prey but was foiled by the lightning-swift reactions of the kudu.

We were all pleased that the kudu had escaped but you had to feel for the poor crocodile trapped in a shrinking pool hoping to catch the odd weakened animal.

Back in Cape Town we were amazed to see how close the croc had come to nabbing its dinner when we froze the video at the moment of attack. That kudu gets a 10 out of 10!

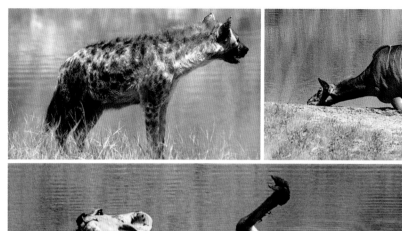

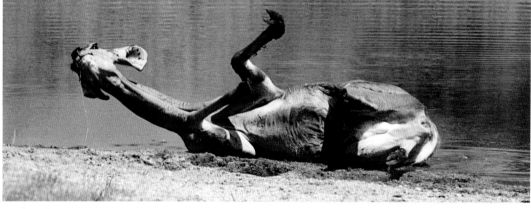

Who Wins?

RICHARD NORMAN CLARK

This tale took place over a two-hour period in the Kruger National Park at Shitlhave Dam on the H1-1 near Pretoriuskop.

Upon arriving at the dam, we noticed a female kudu standing at the water with a hyena nipping at her rump and a crocodile submerged in the shallow water directly in front, waiting to ambush her. After about 10 minutes, the hyena gave up and retreated into the bush and we didn't see it again. We couldn't understand why the kudu merely continued to stand at the water's edge as if in a trance.

It was only after examining my photographs that I noticed the kudu had a severely broken left leg. This injury obviously hindered her movements and had attracted the attention of the hyena and crocodile.

The sweltering heat of midday and thirst obviously got the better of the kudu, who like a drunken sailor staggered slowly (no doubt in a lot of pain) to the water's edge. After several attempts to spread her front legs in order to drink were unsuccessful – her broken leg was hamper-

ing her normal mobility – she stumbled and fell in such a way that her back and head were in the water with her belly and legs on dry land.

The kudu made many feeble attempts to get onto her feet but failed. Her struggles continued for some 20 minutes without any further sighting of the hyena or crocodile.

After what seemed like an eternity, the crocodile reappeared, as if by magic, for an easy meal. It approached cautiously and tried to get hold of the kudu by her rump. This didn't work, so it reassessed its strategy and closed its powerful jaws around the kudu's mouth and dragged the body a bit further into the water, thereby mercifully drowning the fatally injured animal.

The commotion in the water attracted the attention of the only hippo in the dam, who felt his territory was being threatened. He moved into attack mode, quickly making his way to the crocodile and dead kudu. The crocodile immediately beat a hasty retreat, but the dead kudu did not oblige and stayed in the water, seemingly

challenging his authority. In a display of power, the hippo stamped his legs in the water, snorted, mock-charged and did everything possible to evict this outsider. After 10 to 15 minutes of this show of aggression, he quietly retreated to deeper waters, his dignity in tatters.

The crocodile returned and, after much difficulty and a demonstration of tremendous power, eventually moved the entire kudu into the water.

It began its feast by attacking the softer parts of the kudu and managed to rip an ear off after a prolonged death roll. It dragged the kudu carcass across the dam to deeper water and out of our sight.

The battle between the hyena, crocodile, kudu and hippo demonstrated the ever-changing balance of power in nature and how the fittest are the ones to survive.

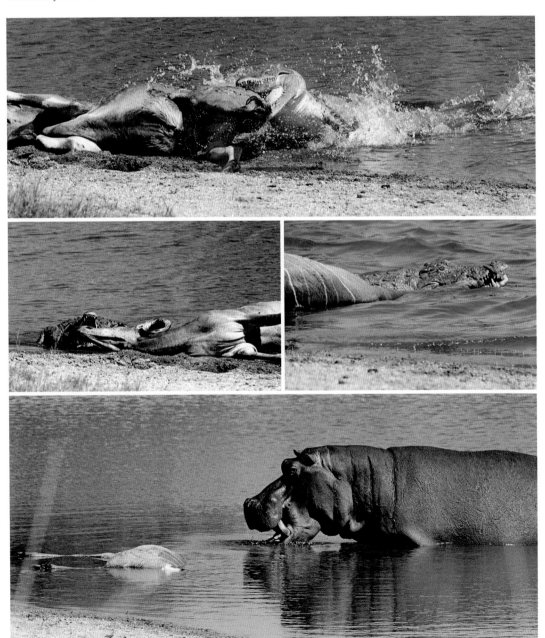

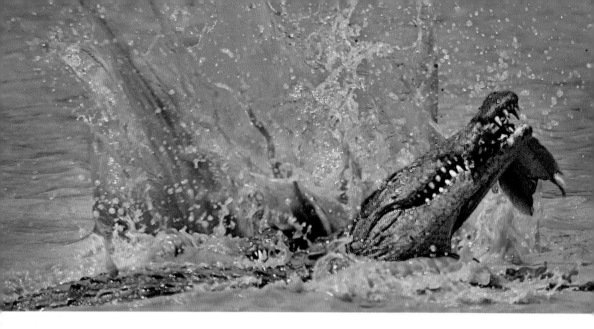

The Crocs and Barbel Show

KOOS FOURIE

An early-morning game drive had us cruising languidly through the Tshukudu Private Game Reserve in the Hoedspruit area. We stopped at the perimeter of a shimmering dam, where two lethargic crocodiles were basking lazily on the sand, their rough scaly skins absorbing the beams of the sun. Our presence disturbed them, dragging them from slumber, whereupon they reluctantly moved towards the water's edge and then in a slow, sleek movement vanished into the shimmering water.

We were having an interesting discussion about a crocodile's diet when my eye caught something white about 30 metres into the dam. My immediate and agitated conclusion was that it was a white plastic bag, also known as the "national flower of South Africa". I was profoundly annoyed by the short-sightedness and irresponsibility of whoever had discarded it, most particularly in a game reserve.

Looking through my camera's zoom lens though, I was relieved to see that it was not a plastic bag after all but instead the white gullet of a huge barbel. The colossal barbel was firmly clinched inside the sizeable jaws of one of the crocodiles that had swum away from us just a few minutes earlier. The barbel was frantically struggling inside the monstrous rows of jagged teeth.

From time to time, the crocodile lowered his prized catch into the water, and the submerged barbel renewed its struggle even more fiercely. The brownish water was splashed in all directions, droplets flying and falling as if snatched by gravity into the murky water. All the action and commotion attracted the attention of the second crocodile and its glinting eyes appeared above the waterline.

Then there was a watery explosion as the other crocodile tried to latch onto the barbel as well. As they skirmished, the gnarly heads tugged and pulled, with both reptiles struggling to gain control. The barbel was torn to pieces, sending blood-spatter into the air. The frenzied pandemonium was over in a flash.

The first crocodile swam away with a bloody half-a-barbel in its jaws. The second crocodile was clearly unsuccessful and had nothing to show for its attempted theft. Its half was probably on the muddy bottom of the dam.

The ripples diminished and the water's surface became smooth and glittering. There was no sight of that characteristic armoured skin. The sounds of chirping birds in the trees became evident again, their songs playing over the now tranquil water. The ranger started the vehicle and we continued on our morning drive.

Crocodiles Can't Chew

HAMMAN PRINSLOO

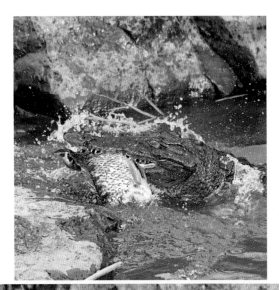

I found this young Nile crocodile on the H10 bridge close to Lower Sabie in the Kruger National Park. He was lying stock-still with a fish in his mouth: it must have been moments after he caught it. Then he began to move. He slowly lifted the front of his body out of the water and then dropped back into the water while shaking his jaw with the clenched fish from side to side in an attempt to tear the fish into smaller, more manageable pieces. He did this repeatedly until he could swallow the fish in fragments. It is quite a mission to eat when you are unable to chew!

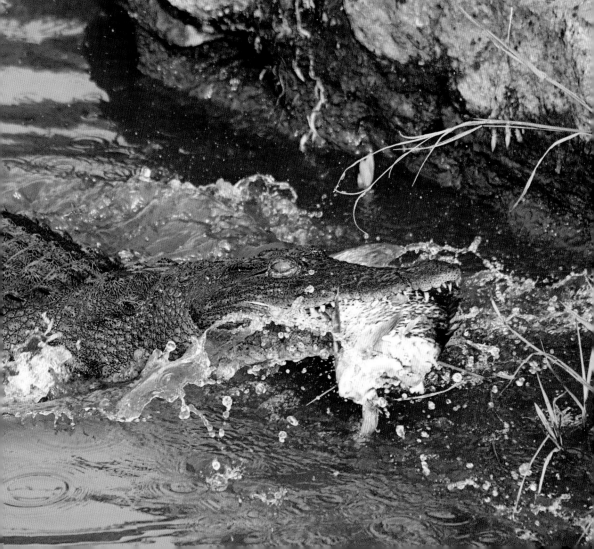

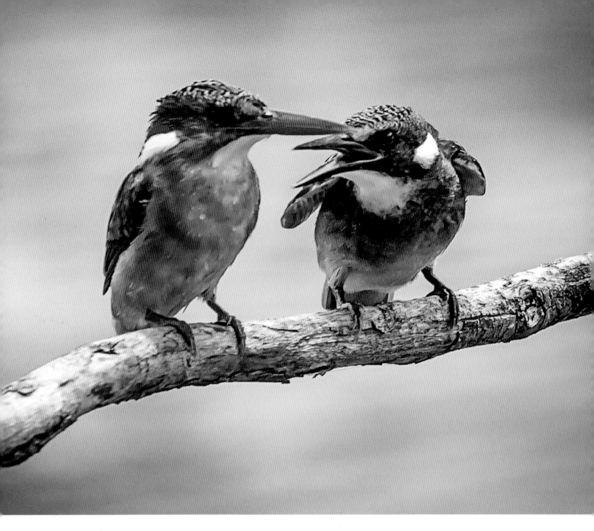

Grade R for Malachite Kingfishers

MICHAEL J SKELLERN

I was sitting in a hide at a dam near Port Edward, KZN, hoping to photograph waterbirds. A pair of malachite kingfishers landed on a branch stretching over the water, just close enough for my tele lens.

The pair was quite animated and I soon realised that they were a parent and a youngster because there was one with a red beak (the adult) and one with a dark beak (the youngster). The younger bird was demanding to be fed. It could clearly be seen telling the parent to go and catch dinner. The parent eyed the water and then made a dive but had no luck. The next dive, however, was successful and the parent arrived back on the branch with a small fish (tilapia rendalli) in its

beak. The young bird became wildly eager and a flurry ensued. The parent eventually gave its off-spring the fish by shoving it down the youngster's throat, instead of risking it falling into the water. The junior kingfisher immediately swallowed its meal and the pair split up.

Later, I noticed a young bird, possibly the same one, sitting on a reed low down near the water and staring intently downwards for some minutes. The bird then dived and returned to the perch with a boatman water insect held firmly in its beak. Was this the training young kingfishers receive, working up to hunting and catching fishy meals? Even at a tender age, its eyesight and accuracy were obviously not lacking!

Kingfisher Squadron

ROLF WIESLER

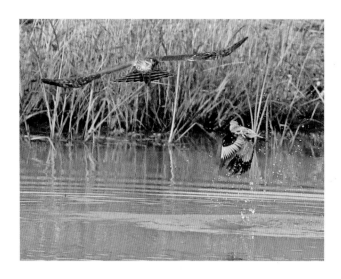

After a productive afternoon game drive in the Greater Kruger National Park, we stopped for sundowners overlooking a small dam. While enjoying a drink I noticed a gabar goshawk flying above the reed beds adjacent to the dam.

While following the gabar goshawk in the camera's viewfinder, I noticed that it had flushed a malachite kingfisher from the reeds and was chasing it. A few seconds later I was astonished to see a woodlands kingfisher, which had been perched in a tree nearby, appearing to 'fly interference' between the gabar goshawk and the malachite kingfisher. As the woodlands kingfisher flew between the two birds, the goshawk was immediately distracted and started chasing the woodlands kingfisher, eventually forcing it into the water and then hovering above it.

Next – there was no other way to interpret it – the malachite kingfisher came to the rescue of the woodlands kingfisher by flying in close to the hovering goshawk, enticing the goshawk to go after it again. The malachite kingfisher, how-ever, was forced to take serious evasive action and also landed in the water. In the meantime, the woodlands kingfisher had emerged from the water and once again flew past to distract the gabar goshawk, allowing the malachite king-fisher to make its escape. The entire sequence ended with both the malachite and woodlands kingfishers home free.

I was astounded at this evidence of two differ-ent kingfisher species working in tandem to en-sure they both evaded capture by the aggressive gabar goshawk.

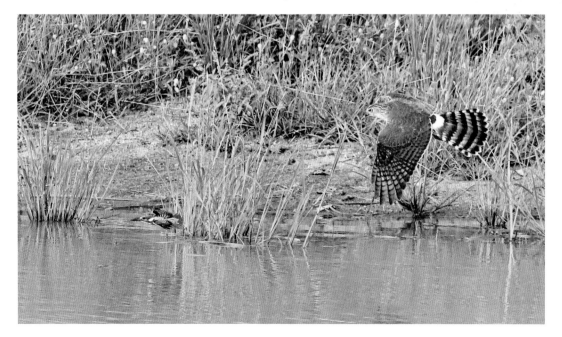

A Different Path to Romance

HAMMAN PRINSLOO

We witnessed this event on one of our trips to the Kgalagadi Transfrontier Park. We found a lone cheetah female in the Nossob Riverbed resting under a tree. After a few minutes she got up and moved further south along the riverbed. This caught the attention of a coalition of two male cheetahs and they came onto the riverbed too, stalking the female. She was quite unaware that she was about to receive company. The two males dashed towards her and attacked her aggressively but she put up a good defence. They got the better of her, however, and she was forced to submit after their razor-sharp claws had flown through the air a few times. The males then sniffed her thoroughly, probably to determine if she was in oestrus.

We interpreted this as courtship behaviour. It provided a great adrenaline rush to watch these animals, of the same species and opposite sex, fighting one another. It's not quite how we human males would go about winning a lady's heart but it works in the wild.

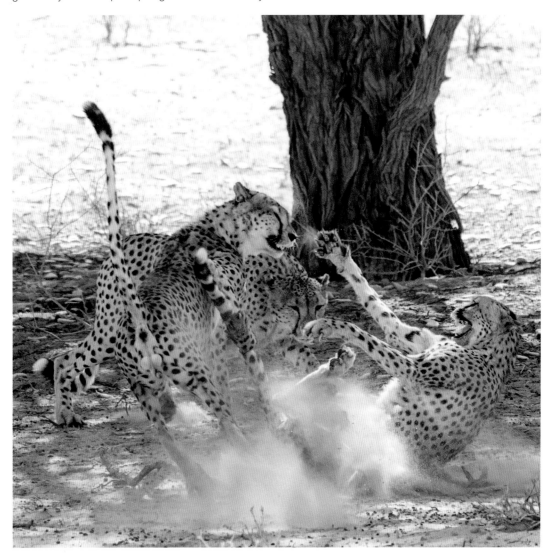

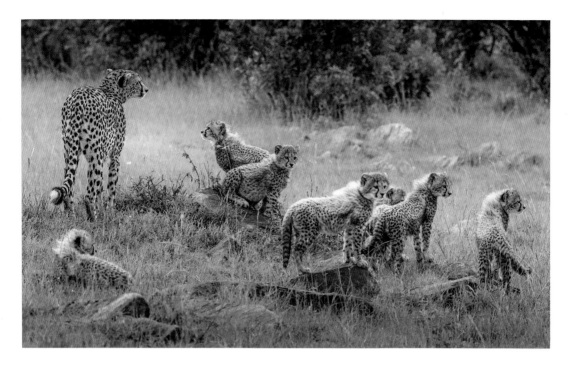

Seven Times the Joy

PAUL VORSTER

'Jambo Rafiki!' beeped the WhatsApp message from Samuyan Kaleku, our long-time friend and Maasai Mara guide.

'Siligi the cheetah has had seven cubs!' Sammy exclaimed, as proudly as any father.

An announcement like that is enough to put all other plans on hold, including our holiday to the sea. Knowing my wife Barbara's passion for cheetahs, I just knew we wouldn't be driving south to the coast, but flying up north to the Mara where Siligi was waiting for us.

Holiday luggage was swapped for bush clothes and camera gear, and Sammy put on standby to collect us at Keekerok airstrip.

It was an extremely wet December, with slippery roads resembling narrow rivers and the tall grass a true emerald green. This was lucky for us because the rain kept safari vehicles to a minimum and we were often the only visitors enjoying the sight of Siligi and her cubs. The lure of this special family had us out bright and early, eager to drink in every moment we could of observing Siligi and the cubs as the first light warmed them up from the night's chill in the wet grass.

Siligi was a superb mother; she suckled them; she hunted a very young impala to feed them tender meat; she let them play with her to practise their skills, and watched over them as their wrestling matches and mock-fighting escalated into some real sibling disagreements, only for the cubs to be best friends again seconds later.

At all times she kept a mother's caring eye over them and tucked them in under a tree against the rain and cold of night.

Seven cheetah cubs, so busy exhibiting all the energy and charm of wild kittenhood that it was virtually impossible to get all seven and maternal Siligi into the same frame.

Seven cubs... the ultimate wow!

The last message received was that, of the seven, two cubs have survived. The world record goes to a cheetah that gave birth to eight cheetah cubs, the largest litter ever, but they were born at the Saint Louis Zoo in the US state of Missouri, meaning the world record for a cheetah giving birth in the wild belongs to Siligi.

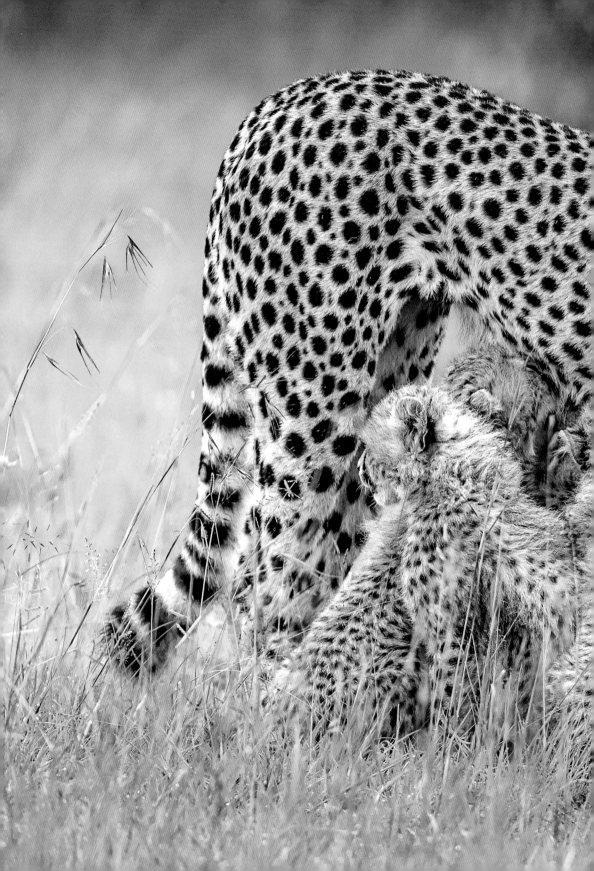

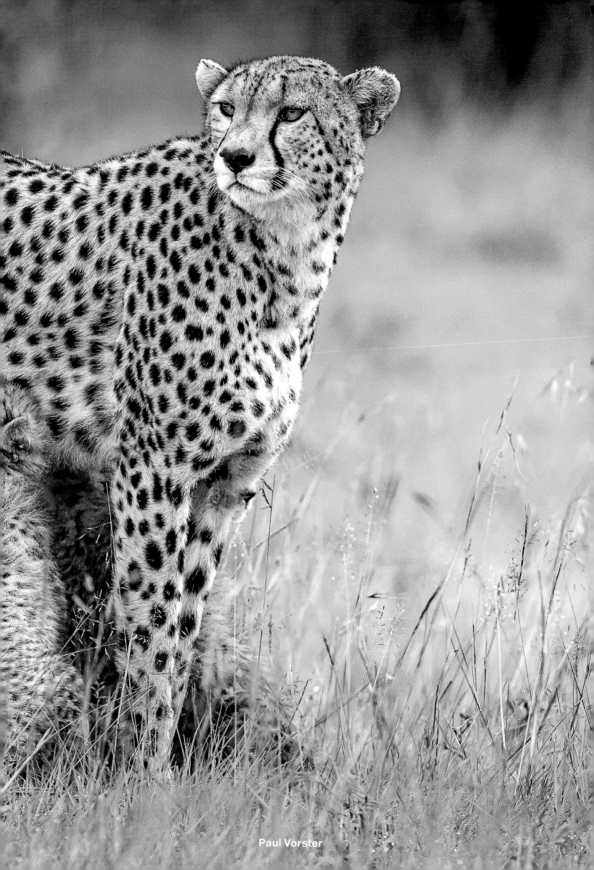

Paul Vorster

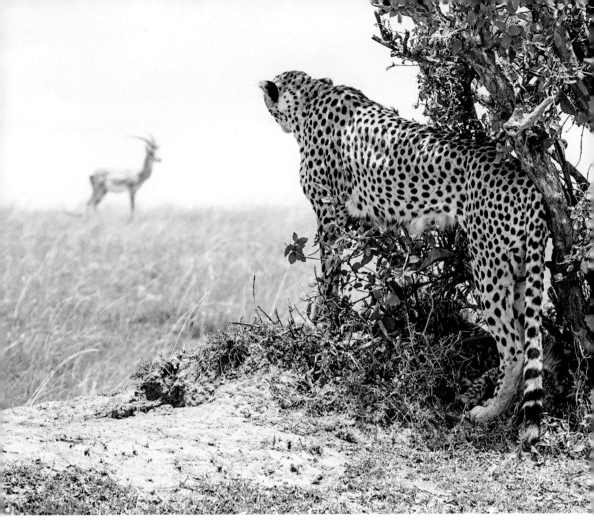

Bringing Home the Bacon

GAVIN DUFFY

One of the highlights of a trip to Maasai Mara in Kenya was observing a cheetah and her cubs searching for and hunting prey. We followed them for quite some time and noticed how they would use anthills or higher ground to observe and find a potential quarry. They kept moving, however, until the adult female found an anthill which had secluded bush and foliage, into which the cubs moved to conceal themselves.

The mother continued to look for prey and eventually spotted a gazelle ram in the distance. The cubs, meanwhile, did not move, hiding in the bush.

Suddenly, the female went into a crouch and our Maasai guide indicated she was about to chase down the gazelle. We decided to remain in the vicinity of the secluded cubs rather than speed off and try to keep up with the chase and mad scramble of dozens of game vehicles vying for the best spot to observe the kill.

Our decision paid off as most of the vehicles could not keep up with the world's fastest predator. We were rewarded with the cheetah returning to the cubs with her kill and resting in relative seclusion with them, before biting through the tough skin of the gazelle to enable the cubs to feed while she kept watch.

We felt lucky to have observed the close interaction between the cheetah mother and her three cubs, and really grateful that we had been given this special opportunity.

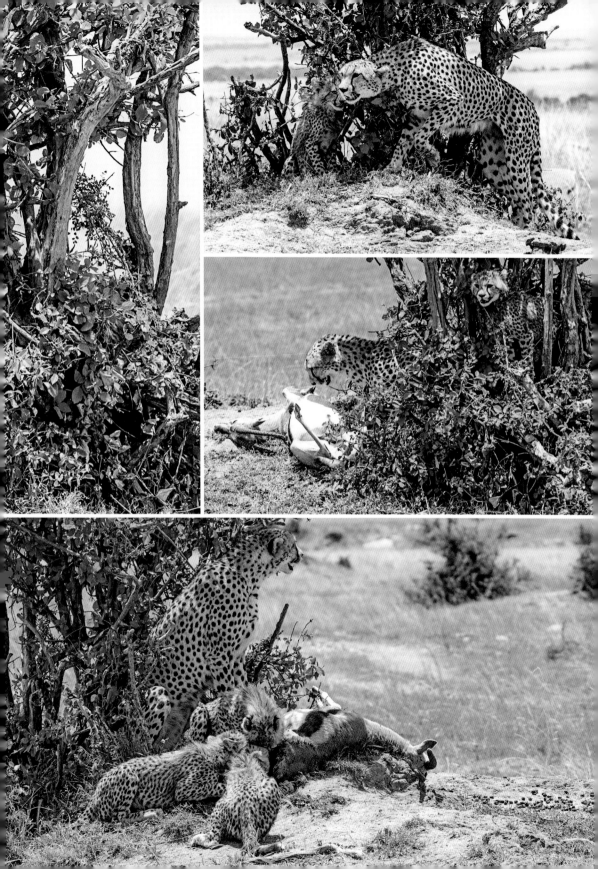

Share and Share Alike

MARIUS KRITZINGER

Namibia was in the throes of its worst drought in a decade when we visited Etosha National Park. However, this was a blessing for visitors, who could pick virtually any waterhole and be guaranteed the sight of animals arriving and drinking.

We were fortunate to stay for a few nights in a bungalow right next to the famous Okaukuejo Waterhole. Every afternoon, like clockwork, from about two hours before sunset, this waterhole was visited by different herds of elephants of all shapes and sizes. They always approached from the east and left heading west.

Quenching their thirst was, of course, their first priority after spending a day in the scorching sun with temperatures averaging 35 degrees Celsius, followed by a pleasant cold shower for the adults, while the young ones and teenagers opted for a quick dip. What was remarkable was the orderly way this all happened, each herd was obviously controlled by the matriarch who decided when it was time to leave, to make way for the next herd to enjoy the refreshing – but by now churned-up and murky – cold water. It was the disciplined manner in which they enjoyed themselves, and departed, that I've tried to capture.

But the cherry on top for me was watching them walking away into the dusk with the last rays of the setting sun shining on their wet bodies, a scene you will experience in Africa and nowhere else!

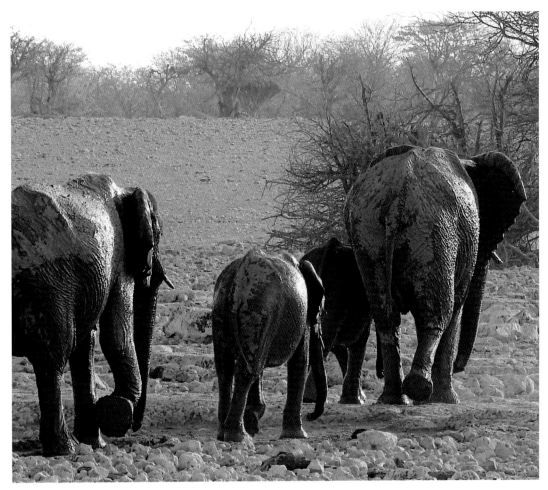

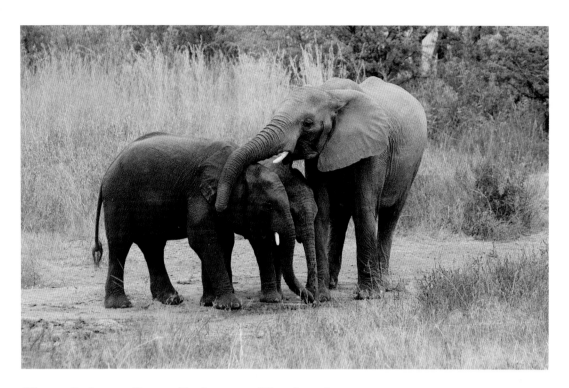

Close Interactions Between Elephants

LESLEY CORNISH

We were at one of our favourite places, Mankwe Hide in Pilanesberg, and were delighted to discover that close to the walkway was a herd of elephants. Most of them wandered off into the bush, including a cow with a very young calf. Then there were three, then two. They really seemed to be enjoying whatever it was flowing from the toilet block. If it was from the septic tank, it must have contained minerals that had value for them. A young female seemed to be having fun with a fairly large male calf. Then a larger female and a smaller calf came closer and to our surprise, it was the smaller female who suckled the smaller calf, although it had to push its way in. Before suckling, the small calf put its trunk in the mouth of the larger calf, which is usually a sign of submission. The slightly larger calf tried to muscle in to the suckling pair but repeatedly, and gently, the larger female held him back, either with her trunk or (more often) by raising her foreleg.

Once the smaller calf had finished suckling, the larger female continued to hold the larger male calf back, still gently, and then she wandered off after the other elephants who had already left. The larger calf got closer to the mother and the calf. They seemed friendly with the smaller cow interacting with both calves (maybe she was also gently keeping the larger male calf in his place). We couldn't work out what had happened, unless the larger cow just wanted to ensure the smaller calf got its share.

We know elephants are caring and look after each other, but this encounter revealed a complexity which I had never come across before.

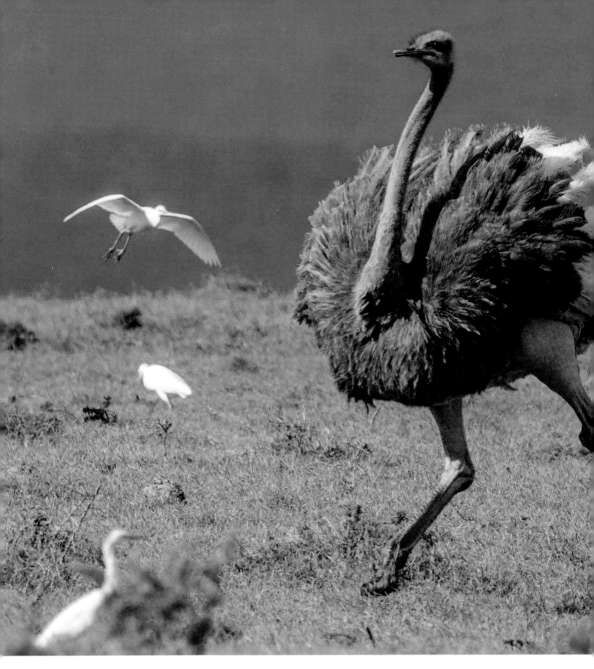

This is MY Family!

JEAN DU PLESSIS

I had never been to the Addo Elephant National Park for an extended visit before, so this eight-day trip was a treat. We were blessed with marvellous experiences: lots of elephants (naturally), hyena and a special sighting of a caracal. I must have taken more than 20 000 photos. But it was a baby

elephant who supplied the highlight with its surprising behaviour.

One afternoon we came across a large elephant herd. We reckoned it was worth stopping to see if anything interesting would occur. We all know that patience and being willing to sit it out are essential when observing wild animals.

The elephants were just standing around being elephants, but suddenly a little bull set off after an ostrich. It looked as if he wanted to chase

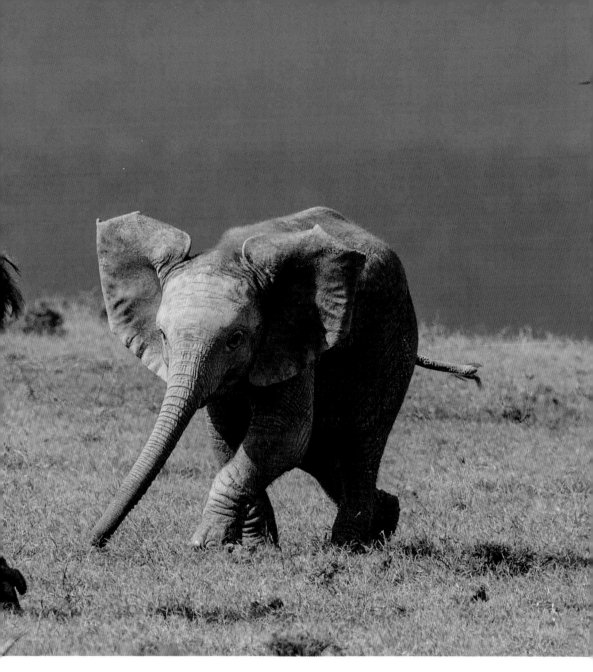

it away from the orbit of the elephants. I'd never seen such behaviour before and we all laughed at the sight.

The ostrich was sent packing but it didn't end there: without warning the herd started running. Perhaps the ostrich had circled round and thrown them into a panic?

And there was Part Two of the encounter. Anyone who has ever seen a herd of nearly 50 elephants stampeding knows that it is an impressive sight. What struck me was how the older elephants protected the little ones, by keeping them in the centre and further away from danger.

The elephants swiftly disappeared into the spekboom forest.

I go to game parks every year but I must admit the sight of a baby elephant chasing an ostrich was not one I'd seen before (or since, come to that).

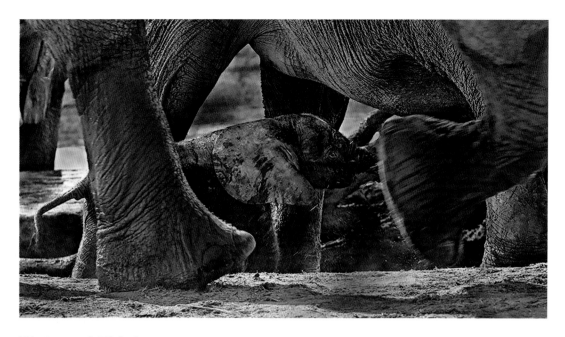

Maternal Tidying-up

KOOS FOURIE

At the raised hide next to the waterhole near Shumba Campsite, Hwange National Park in Zimbabwe, I settled in with my tripod and camera. The sweltering heat of a late afternoon in October rose up from the arid, barren ground, attacking us mercilessly. My eyes scouted the vast expanse, taking in the impala, kudu, zebras, various bird species as well as a small herd of elephant close to the water outlet into the dam. I could smell the heat, the elephant dung. Plovers' shrill calls and the buzzing of cicadas broke the silence.

Presently my eyes were drawn to some activity among the colossal elephant legs. A tiny elephant calf, barely visible, was struggling to get up. As the dust curtain settled, I saw the mother nudging the wobbly little calf onto its feet and it greedily began to suckle. Understandably, the cow was nervous and uneasy because of the danger to her newborn from predators. It was only then that my eye caught the slimy heap of the afterbirth on the dusty sand in front of her. With her calf still suckling, she gingerly stepped forward and, much to my surprise, attempted to eat the afterbirth. This obviously did not suit the delicate palate of a herbivore. Next she tried to toss the afterbirth onto her enormous head but it just slipped off and

slopped down onto the warm sand. I assumed she was trying to get rid of it as the smell was an open invitation for any predators nearby, drawing them to her baby. Bright red splashes of blood covered her head, seeped from her mouth and ran down the front of her wrinkly legs. Eventually she gave up and began to amble away from the waterhole, constantly assisting her little one and guiding it in the direction of the nearby bushes.

No sooner had they left when birds of prey flocked down from all directions onto the afterbirth. A cacophony arose as each of the feathered predators fought for a piece. Their flurry was obscured by curling whiffs of dust, their squawks displacing the silence. The elephant and her calf walked away in a leisurely fashion, oblivious to the commotion and disappeared into the bush. Not long after, the blistering sun began to set behind the cloudless horizon in hues of oranges, yellows and peach. The sounds of the night slowly took over from those of the day, indicative of the approach of another nocturnal episode of life in the bush. I played back the events I had witnessed, still filled with amazement and aware of how fortunate I'd been to be at the right place, at the right time, on that day.

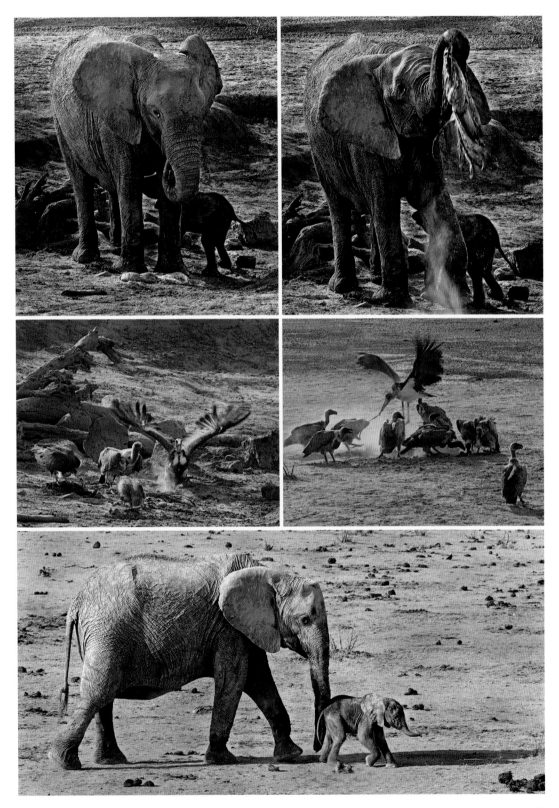

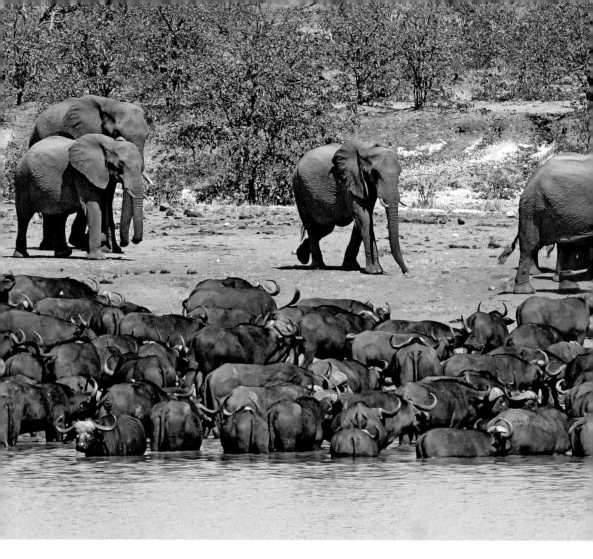

Space for All

TOM VAN DEN BERG

We were parked next to the Sable Dam in the Kruger National Park enjoying the peaceful scenery when the silence was shattered by an approaching buffalo herd. They appeared from behind the dam wall, jostled down to the edge where the entire group waded up to their bellies into the water and started drinking. This was a wonderful sight and we watched, fascinated.

All of a sudden elephant heads appeared from behind the dam wall. They seemed surprised by the presence of the buffalo for they stopped in their tracks, milled about and looked as if they were uncertain about what to do next. Then one of the biggest cows, probably the matriarch, took the lead and, trumpeting and swinging her trunk and spreading her ears, forced her way through the buffalo herd towards the water with the rest close on her heels. This caused a real commotion. Eventually the animals all calmed down and found a place to drink despite being packed together side by side.

That these two dominant groups managed to share a precious resource seemed like a lesson for mankind. We felt privileged and grateful to have seen this unfolding drama.

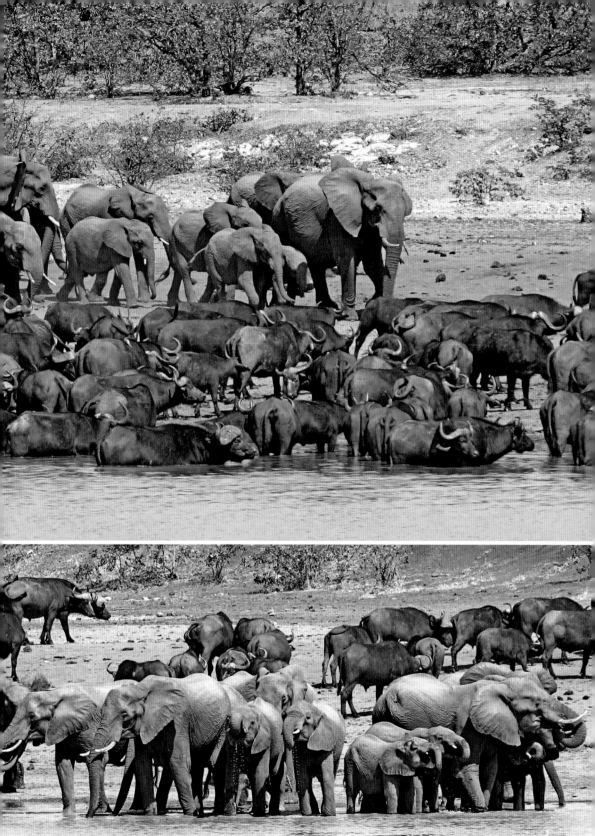

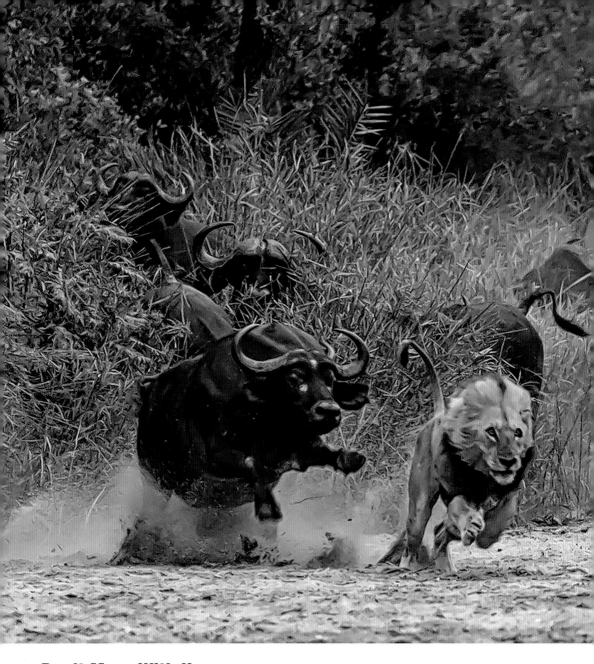

Don't Mess With Us

DAVE WOOLLACOTT

It was dusk and the sky was heavy with rain clouds when my wife and I made our way out of the Kruger National Park in November 2012. As we followed the Sabie River on dirt road S3 to the Phabeni Gate, we came across a herd of Cape buffalo lying in a dry riverbed. At that moment, a lion appeared over the rise of the left bank and tried to attack one of the buffalo. The herd responded quickly by chasing off the lion, across the river bed and into the undergrowth. The lion ran off with its tail between its legs. A case, once again, of biting off more than you can chew...

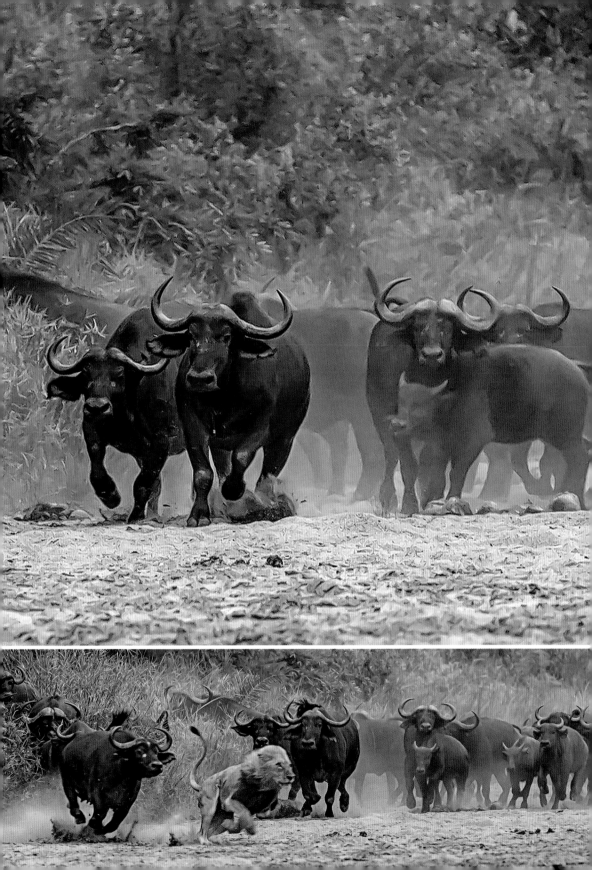

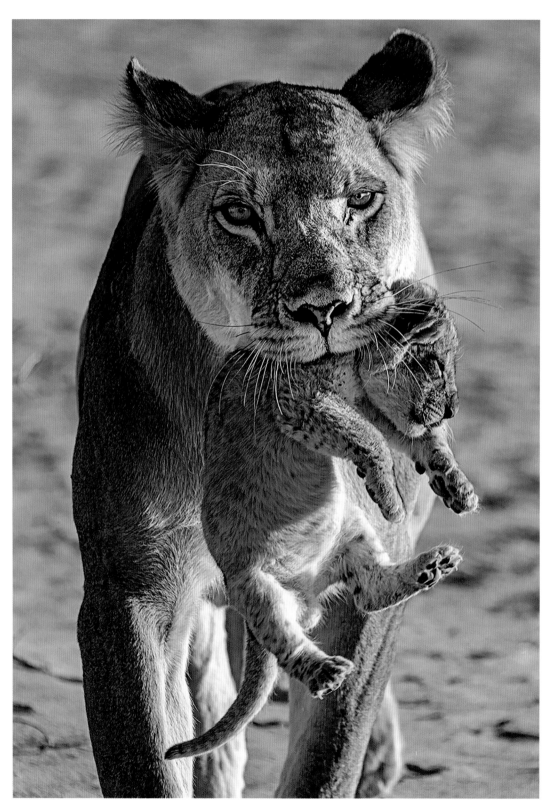

Now, Where's the Best Place?

RUDI ZISTERER

One early morning in November 2019 at Monro Waterhole in the Kgalagadi Transfrontier Park I saw a lioness carrying something in her mouth. Through my binoculars I saw that it was a cub. She came directly towards me and it seemed obvious that she was looking for a new hiding place for her baby. She found a spot on the other side of the road under a bush, about 20 metres away from my car. She walked back, crossing the road in front of me to the other side of the riverbed, where she picked up a second cub from a small cave. She took the same route back, crossing the road again and placed the second cub under her chosen bush. Then she went back to the other side of the riverbed to pick up her third cub.

But then something put her off. She took the third cub to another small cave close to the original one and had to repeat the journeys in reverse back over the riverbed for the first two cubs to deposit them in the second cave. Maybe she decided a cave was a much better hiding place for the cubs than the bush which was so close to the road.

This was a great sighting. It was fascinating to try to guess what was going through the lioness's mind and I felt privileged to witness this display of motherly concern.

A Distant Roar

ARMAND GROBLER

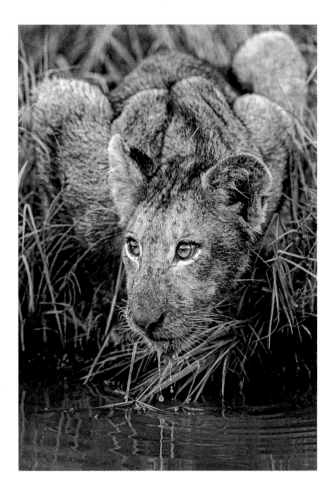

It was a warm summer evening as we sat in the *boma* of Elephant Plains Game Lodge under the open African skies. I picked up snatches of conversations about the day's adventures; all these different people united in their appreciation of Africa's bounty.

During the night, I woke to the sound of a lion roaring. I went outside to listen more intently to that distinctive, echoing call. His roar set off the other lions in the vicinity and a deafening chorus spread across the savanna. There was definitely something going on and excitement kindled in me in anticipation of what lay ahead the next day.

On the morning drive, our guide told us that a recent buffalo death would have attracted the local Nkuhuma pride, the reason we'd been treated to a leonine symphony the night before.

As we proceeded, we noticed vultures and spotted hyenas: clear evidence of a carcass nearby. Then a movement of tawny fur caught Dillion, our guide's attention before we stumbled across the entire pride lying just off the side of the road. It was a sight to behold as females, a male and tiny cubs (some only nine weeks old) came into view. They viewed our slow, careful approach curiously. The cubs played in the road and grass, the females slept belly-up and a male was feeding on the buffalo carcass; no doubt the latecomer to the party and the one I'd heard the night before. We were intrigued to see how nature provides not only food, but toys as well: the cubs were playing with the buffalo skull like an overly large soccer ball.

Fifty metres further on, we came across another male and female, sleeping on the road, completely oblivious to us. We realised they were a honeymoon couple, slightly apart from the others. They set about increasing the local lion population. After a few seconds of action, they separated and fell asleep again, only to repeat the process a few minutes later. A hyena running by prompted them to lift their heads slightly in annoyance but the urge to sleep won.

Days later, we tracked the pride to where they had crossed into the neighbouring property. We were disappointed, but then our guide spotted a dead impala in a marula tree fork and we noticed two leopards playing a game of 'cat and mouse', completely unaware of us.

Xidulu and her cub Cara were having a ball as they romped on the grass and fallen trees. Pools and termite mounds became their obstacle course. They only stopped occasionally to make sure there was no potential threat nearby. Excitement and amusement mingled as we watched these felines acting like domestic cats. The cooler weather made for perfect playing conditions and the odd snack on the impala fuelled their energy.

The following evening around the boma, cheerful chatter and laughter could be heard as we shared our stories, under the vast African skies…

A Tale of Two Lions

BARBARA JENSEN VORSTER

In the Maasai Mara there is a lion called Benna. He is one of the three rulers of the Black Rock Pride with his brothers Longo and Orikini. The Black Rock Pride is one of the biggest prides of lions in the Mara and by far the most cohesive. Benna is a *shujaah sana* – a 'big warrior'. He has paid the price for defending his pride and his Sopa Valley from intruders: he has lost one eye, has a permanent limp and from time to time some form of neurological degradation can be detected. But, make no mistake, Benna is firmly in control of his pride and the pride takes good care of him. This has become particularly evident since mid-2020, because Longo had been missing from early 2020, and Orikini has not been seen since March 2020.

I have a special place in my heart for Benna. There is something about him when he looks at you with that one eye which is unique. You can't help but be drawn by that soulful look.

Early one morning in March 2020, just after sunrise, we spent some time with the pride. They'd just woken up and after the ritual of greeting each other, they were getting ready to hunt as there were some buffaloes not far away. They all, the lionesses, sub-adult offspring and young cubs, walked off quickly towards where the buffaloes were. Except Benna and one cub…

Benna struggles to become mobile after a night's sleep due to his arthritis (it was a very wet morning which isn't good for the old lion) and he was meandering some length behind the pride. There was this little mite of a cub that didn't let Benna out of his sight and kept looking over his shoulder at the older lion, calling to him like a lioness would call her cubs. Every time Benna stopped walking, the cub would call him and then wait for Benna to catch up. I have had many special sightings but this is the one that tops the list by a mile! I cried so much while I was taking the photos that many of my photos were out of focus…

The Kipling quote "You'll be a man, my son" came to mind as I gazed at the cub and predicted, "You'll be a brave lion, little cub"; a lion that will not only feed his pride, but also maintain its social order. I wondered why we are inclined to label animals as dumb creatures, when it is evident that they have lives that are multilayered and complex, with social sophistication and loyalties that human beings can seldom match.

I felt sure it was Benna's genes that went to make up the little cub's personality, and that the Sopa Valley could look forward to another *shujaah*!

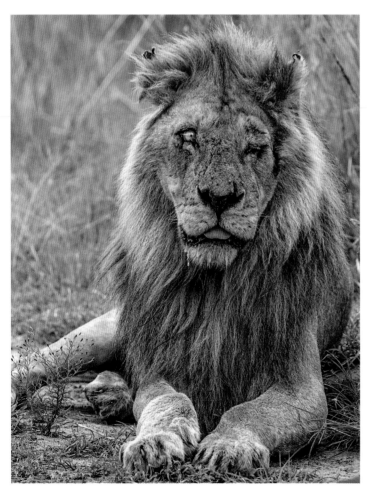

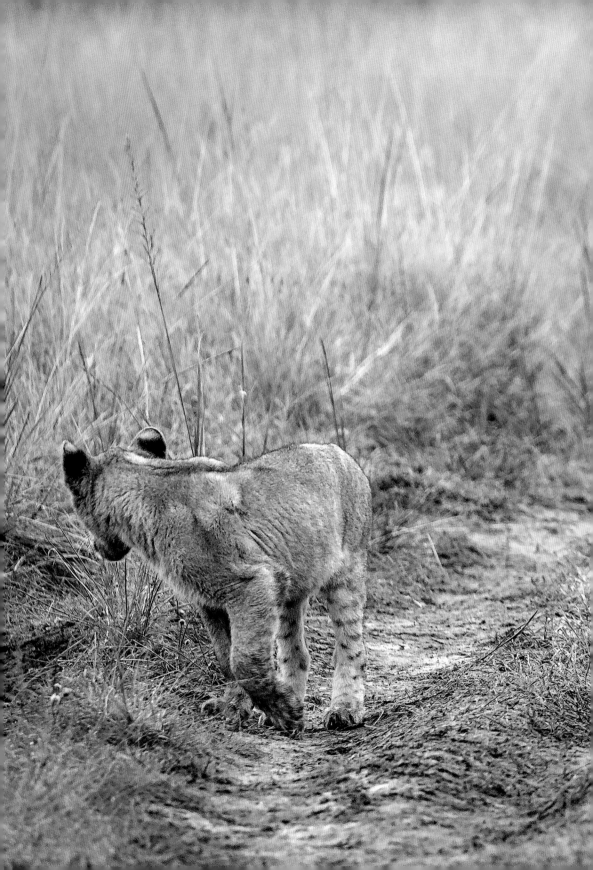

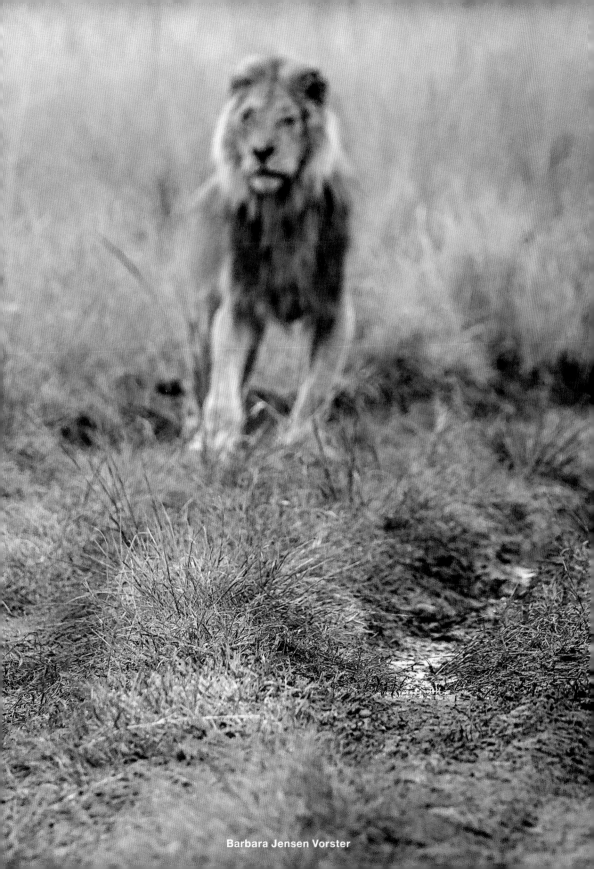
Barbara Jensen Vorster

Black Socks

DUSTIN VAN HELSDINGEN

Black Rhino Private Game Reserve is situated within the western portion of Pilanesberg National Park. It is a private concession within the park and animals are allowed to move freely between the two reserves. We had been to one of the lodges at Black Rhino Game Reserve twice and, on both occasions, we had a fantastic, relaxing time with family, coupled with great wildlife sightings.

The second visit was in September 2019 before the summer rains arrived. It was very dry and the areas that had been burnt earlier in the winter had not yet started to sprout. Our first game drive on the afternoon we arrived turned out to be rewarding. After a quiet start, we found and spent some time with a herd of elephants as the sun was setting. We moved on as the last golden rays were dimmed and spotted a lioness with two cubs walking across one of the plains. They stopped for a drink at a small tributary and then waded across the water, still half-asleep from their daytime slumber. The area they entered had recently been burnt, so each step generated a puff of black dust and their golden-yellow coats created

an eye-catching contrast against the black backdrop. As they moved across the road close to our vehicle, we saw, to our amusement, that the cubs had gained black 'socks' from the combination of wet paws and soot. The two energetic cubs fell behind the lioness on a number of occasions but always stuck close to each other as they romped and mock-fought.

The lioness saw a lone elephant bull not too far in the distance and lay down, waiting for the potential danger to pass. The two cubs caught up and lay down next to her, demonstrating affection both towards their mother and each other, and continuing to play without a care in the world.

Getting the chance to observe the bonds within an animal family is like receiving a gift. Watching and listening deepens our understanding of these bonds and relationships that exist between animals. We need to spend time observing and listening to appreciate these special moments – special moments that become etched in our memory forever.

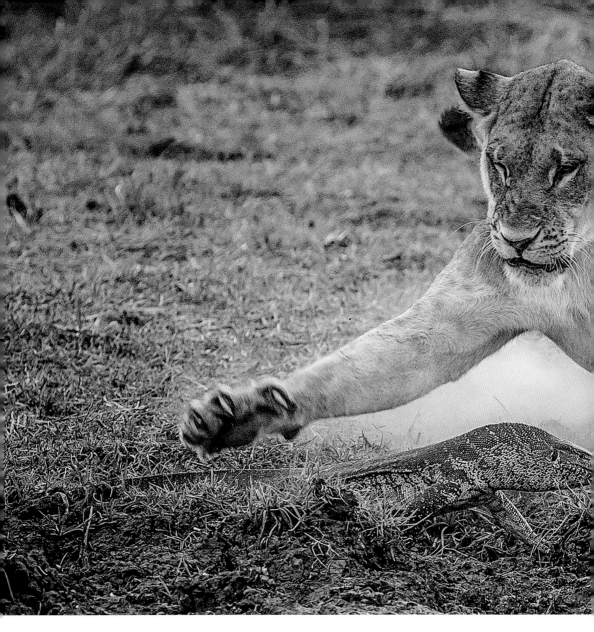

Better Safe than Sorry

FRED VON WINCKELMANN

It was a few years ago on a cloudy October day in the Moremi Game Reserve in Botswana that we came upon an inexperienced young lioness with four eight-week-old cubs that she had just taken out of hiding that day to introduce them to her pride.

While gathering her cubs, she detected an animal that she'd probably never seen before, a harmless water monitor. She stopped the cubs investigating this creature themselves by administering a gentle bite or two.

She took her responsibilities seriously and was taking no chances. She studied the reptile for a moment and then charged the monitor, not once but several times. However, she hadn't anticipated its reaction and was startled when the monitor slapped her with its tail. Finally, she seemed to realise that it didn't, in fact, constitute a threat to her cubs and allowed the lizard to walk away.

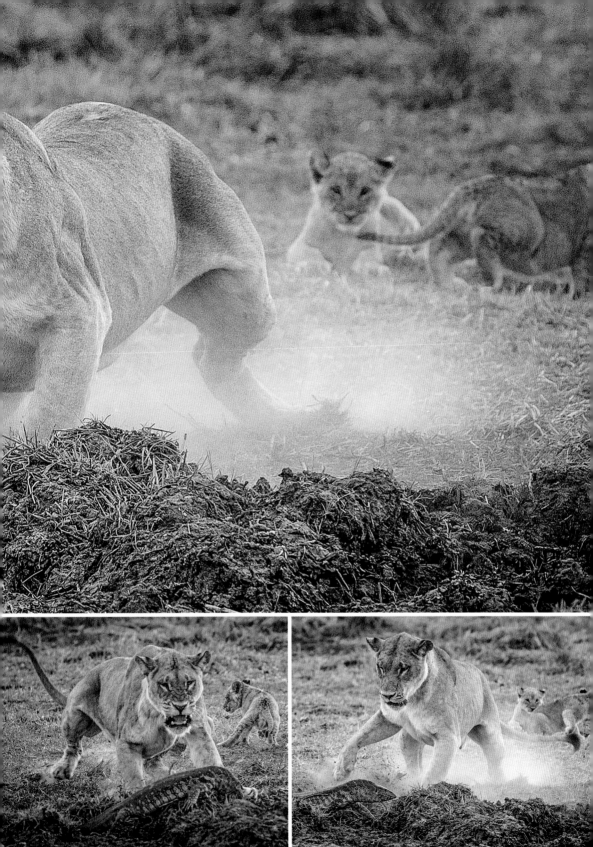

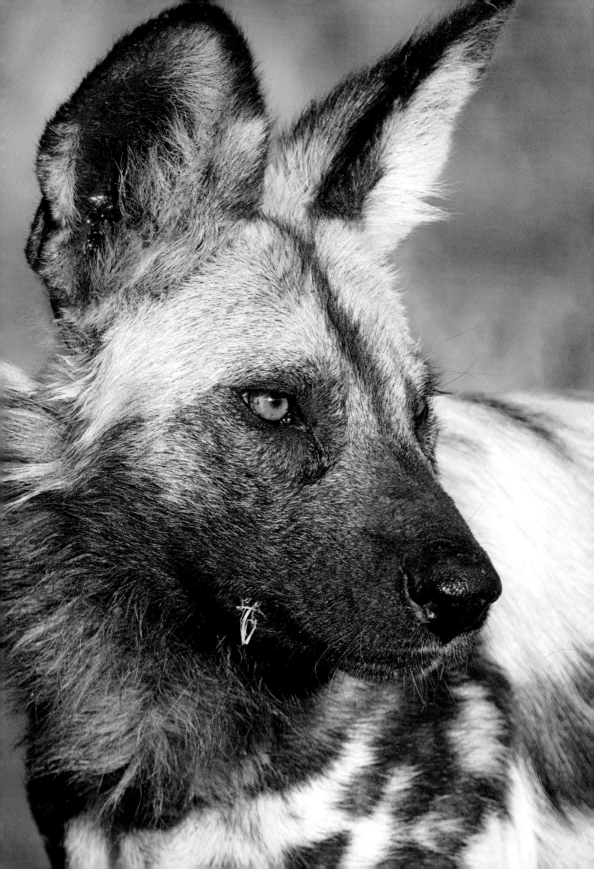

Wanderings Among Painted Wolves

BRUCE CROSSEY

In 2001, there were approximately 150 African wild dogs roaming the Waterberg Biosphere Reserve in South Africa. Fast forward 17 years and only one pack remained.

The Waterberg Biosphere Reserve was where the paths of this last-enduring pack of painted wolves and mine, as a young MSc student, would converge. Two individuals in this pack of free-ranging survivors had been collared and I was given the opportunity of a lifetime: a week of monitoring the last survivors of a wild dog dynasty that has endured all of the hardships that had claimed the lives of every other pack in the area over the last 100 years.

I recall one evening when I was fortunate enough to be alone with the pack. Overlooking a valley of dense scrub, I had seen the pack making their way effortlessly down the hill where their den was located, disappearing into the brush below and leaving the hungry pups with an equally hungry crew of guardians at the den site. In minutes, I was greeted by flashes of black, white and yellow breaking through the bush, flowing past boulders as water does around stone. Searching for individuals that I could recognise, I met a pair of deep-set yellow eyes belonging to the alpha male, Witwater. Blinking, I missed him as he bolted into the bush to the right, deciding to make his way to the far side of where the core of the pack was

congregating on what was now half of an impala carcass. Members of the pack began splitting off: a liver going one way, the torso going another. Particularly striking was that Witwater rarely fed at the carcass. Instead, he skirted those that were preoccupied with feeding and patrolled the perimeter of the pack. He acted as their guardian, as well as their leader. After all the bones had been gnawed and the last pack members melted away into the bush, I sat and waited to see them emerge on the other side of the valley. The pack soon appeared at the base of their den's koppie, nimbly making their way up the rocky outcrop that they called home. The dying light of the day cast long shadows, as their sleek figures wound their way around the guardians and pups who had been waiting for them, now sniffing and chittering excitedly. Meat was hurriedly regurgitated to feed the hungry mouths and it was only then, after all had safely returned and were accounted for, that Witwater finally fed. I felt a deep sadness. Witwater was the last leader of a Waterberg wild dog dynasty defending its lineage.

With more work before us than behind, it is my fervent wish that everyone would heed the words of Sir David Attenborough: "It is surely our responsibility to do everything within our power to create a planet that provides a home not just for us, but for all life on Earth."

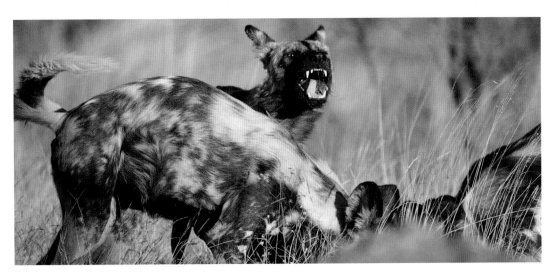

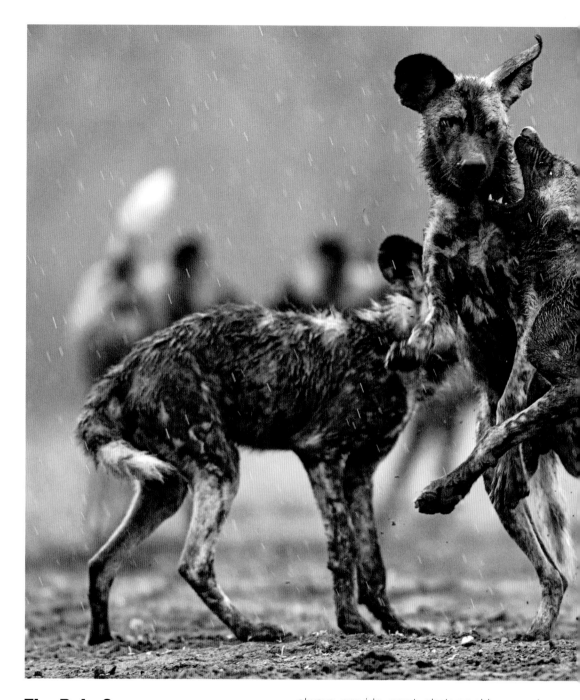

The Rain Games

SEYMS BRUGGER

The African wild dog is one of my favourite animals to photograph. Unlike many predators, they are quite active most of the time and always provide great photographic opportunities. On this day, in the rain, they were extremely playful and, while lying on my stomach on the ground, I had the perfect angle to watch (and capture) them chase, bite and nibble each other. The rain drops add to the mood of the scene, and of the image.

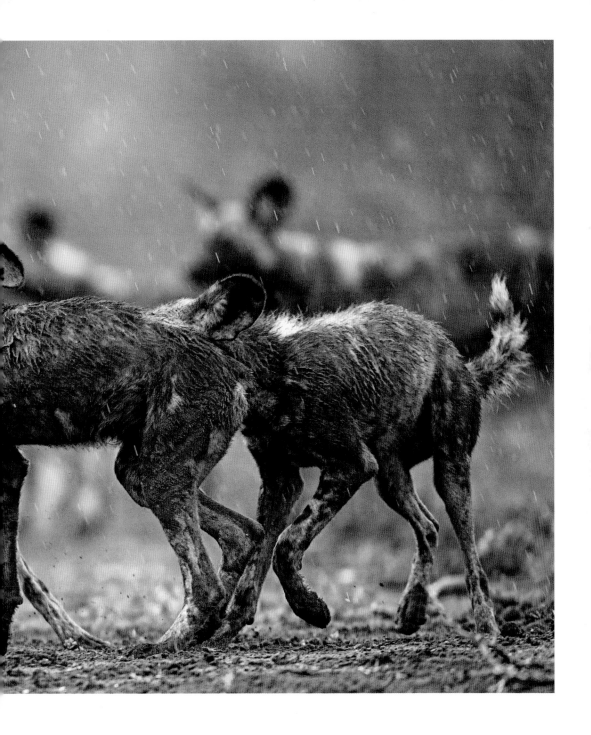

My Wildlife Photographic Creed

EDOARDO MIOLA

I love to photograph animals in their natural environment. Every day, life is renewed, evoking our emotions and giving us joy.

I spend a few months in southern Africa every year, with South Africa, Namibia and Botswana being my favourite destinations. Observing animals allows you to see the world more broadly and acquire a deeper philosophy towards life.

Respect for the environment is essential and I believe one way to demonstrate that respect is to represent it objectively and honestly, without seeking sensational images of nature at all costs.

Landscape and animals come together in a single vision in wildlife photography and give us back serenity and beauty.

Charge!

NIC ANDREW

Facing a charging black rhino is something you never forget. It stirs up deep emotions, mostly fear. The astonishing acceleration. The head held high as it comes rushing forward. The penetrating huffing and puffing while the leathery soles of its feet scrape against the ground. The pause in the charge, followed by deep inhalations as it absorbs information about the unknown in front of it. The continuation of the charge with dust in its wake. An encounter where all your senses go into overdrive.

This animal has engrained itself as my favourite.

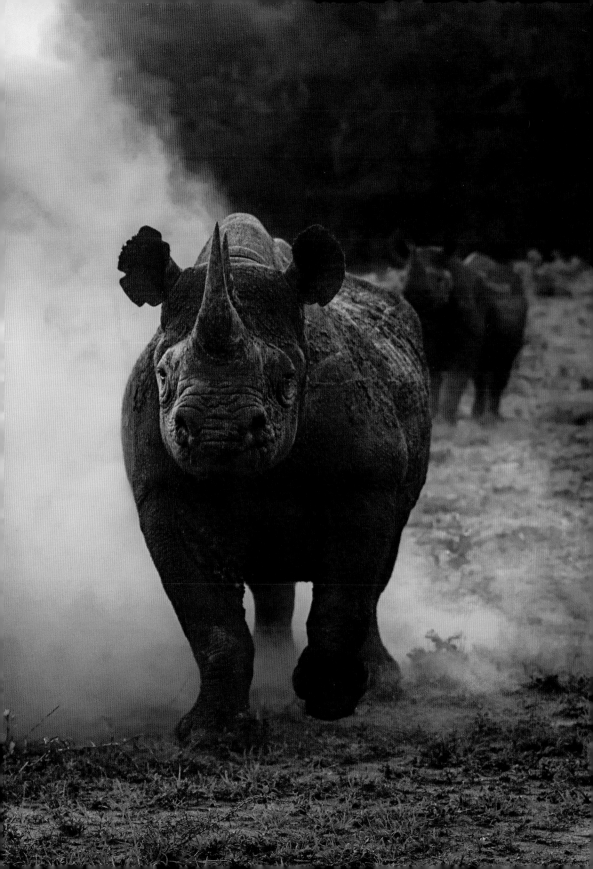

Blue-eyed Rascal

DUSTIN VAN HELSDINGEN

Nocturnal, elusive, secretive and shy are just some of the words used to describe the character of a leopard. It is for this reason that finding one in its natural environment is extremely special and rewarding, sending your adrenaline into overdrive.

It was early morning in October 2018, when I set out from Skukuza Camp in the Kruger National Park, taking in the smells and sounds of a new day breaking in the magical African bush. I had spent several hours the previous two days at a location where people had seen a leopard with her cubs at a den site some days before. I'd had no luck but decided to give it one last try. A kilometre or two before I got to the junction of the road where the den site was located, I noticed a stationary vehicle at a stormwater drainage line and I slowly approached to investigate. "We saw a leopard," the woman called softly, "but we've lost it now." Before the words could sink in, the leopard appeared in the drainage line and walked straight towards us, but she wasn't alone! In her mouth – that same mouth which is feared by the animals she preys upon – she delicately carried a small leopard cub and just behind her was another small cub scurrying along. The sighting I had been hoping for.

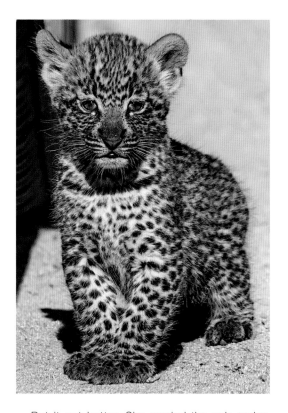

But it got better. She carried the cub underneath the low bridge where we were and we could hear her scraping and dragging vegetation and debris. We worked out that she had chosen this as a new den site. After some time the movement ceased and the female leopard made her appearance, leaving the new den site, perhaps to go hunting. Was this the end of this special sighting? I was just about to leave, when I heard movement to my right and to my surprise I saw one of the cubs making its way up a small tree right next to me. It began to call. Within seconds the female appeared and made her way to the cub, taking it in her mouth once again and returning it to the den. After a few minutes she left again. Would the cubs stay put this time, we wondered? I started my vehicle and made a U-turn to have a view from the opposite direction. Movement... and from the grass next to the road, a tiny head peeked out. WOW! The cub boldly left the grass cover and moved to the middle of the road, sat down next to one of the vehicles and looked straight at me with the most gorgeous blue eyes. A tiny leopard cub, out in the open in broad daylight and just a couple of metres away – little blue-eyed rascal...

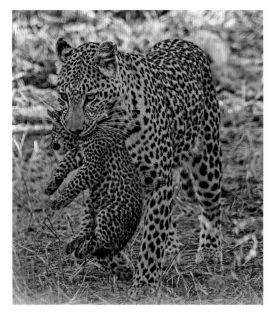

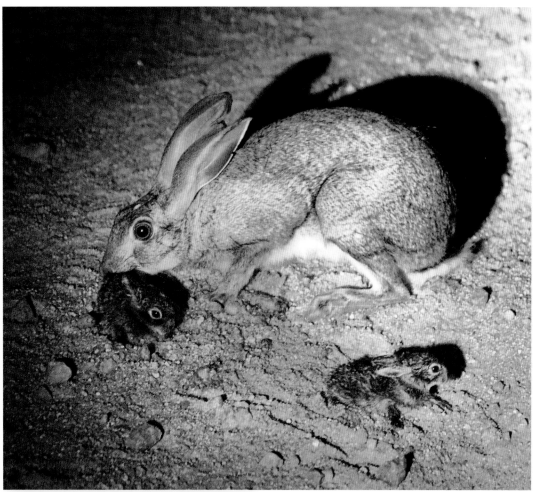

Scrub Hare Birth

HAMMAN PRINSLOO

I was doing a night drive from the Crocodile Bridge Rest Camp in the Kruger National Park when our group stumbled upon an incredibly rare sighting.

A scrub hare sat in the road and didn't move away on the safari truck's approach. We then noticed why. She was busy giving birth.

This is an incredible sighting as many people think hares also gives birth to helpless, hairless pink babies like rabbits. Unlike rabbits, hares give birth to fully developed babies with open eyes and they are ready to walk soon after birth. It was truly remarkable and a sighting I'll remember forever.

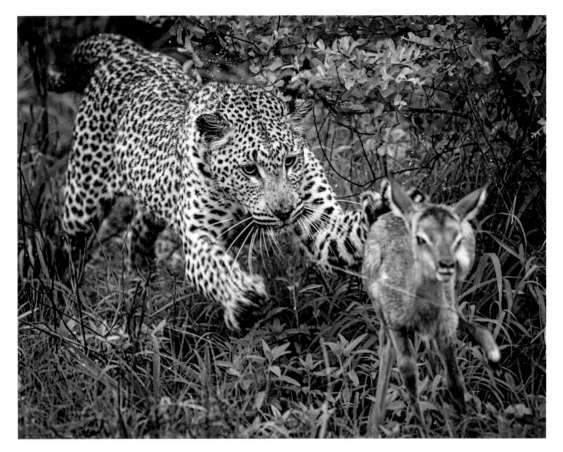

The Leopard and the Lamb

ARMAND GROBLER

It had been an unusually quiet December afternoon at the Elephant Plains Game Lodge in the Sabi Sands Game Reserve. With the rain falling, that aroma of moisture and fresh grass which is unique to the bush, filled the air. The downside was the rain stinging our faces in the open safari vehicle. Nevertheless, I felt keen and eager.

As we drove along the Londolozi boundary after hours of unsuccessful searching, our attention quickly shifted from the feel of the rain to the alarm call of a lone impala antelope peering into dense bushes. It took no notice of us. Our eyes scanned, sniper-like, across the thickets. Minutes passed and then the impala sprang away. Our disappointment was instantly curtailed when we caught sight of a flash of orange. Adrenaline surged as we comprehended what we'd seen. The engine roared as it started, in contrast to the silence of

anticipation until we eventually located her: Tiyani, the local female leopard, padding along with supreme assurance. Her intentions were clear. She was hunting…

Our moods changed from disappointment to electrifying excitement in a split second. Thanks to the impala's alarm call, all other animals nearby would be on high alert and it seemed unlikely the leopard's quest would be successful. Nevertheless, leopards are known to be master hunters and they thrive where most large predators would fail. Tiyani was evidently searching but the male impala wasn't what she wanted, nor did his alarm call distract her from her mission. On she went, as we struggled to keep up.

Like a bullet from a gun, a young impala shot out from the bush with Tiyani close on its trail, slicing at blinding speed through the thick scrub until the inevitable happened. Then the deafening sound of silence, an eerie absence difficult to describe to those who have not experienced it. We caught our breath as we witnessed the capture.

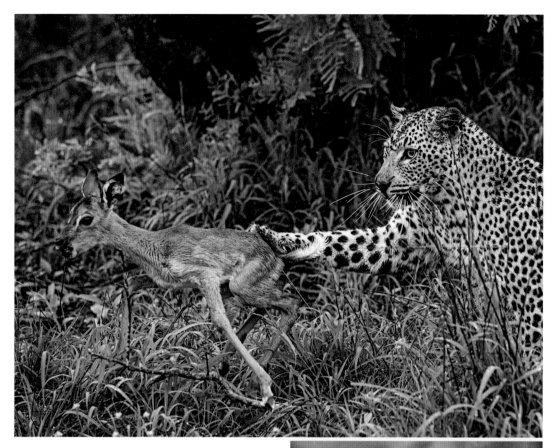

The leopard had caught the young buck, but instead of killing it, she held the helpless creature hostage. The silence was shattered by the bleating from the young lamb, sending chills down my spine. The reason for Tiyani's strange behaviour soon became apparent; she had set a trap to catch the lamb's mother. The helpless cry went unanswered for what seemed to be hours, but was mere minutes and with the danger of approaching hyenas or lions becoming too great, the leopard put a swift end to the young impala's fragile existence.

Such is the cruel circle of life. For these creatures to survive in the wild, they need to eat. Tiyani's behaviour might seem savage but there is always a purpose behind animals' actions.

We sat with mixed emotions trying to simply accept nature's ways, instead of imposing our human perspective. After all, we had just been granted an incredible sighting. It also proved that you should never stay in bed when it's raining or you might miss something astonishing.

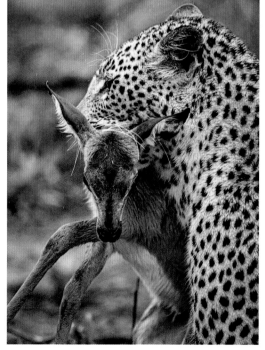

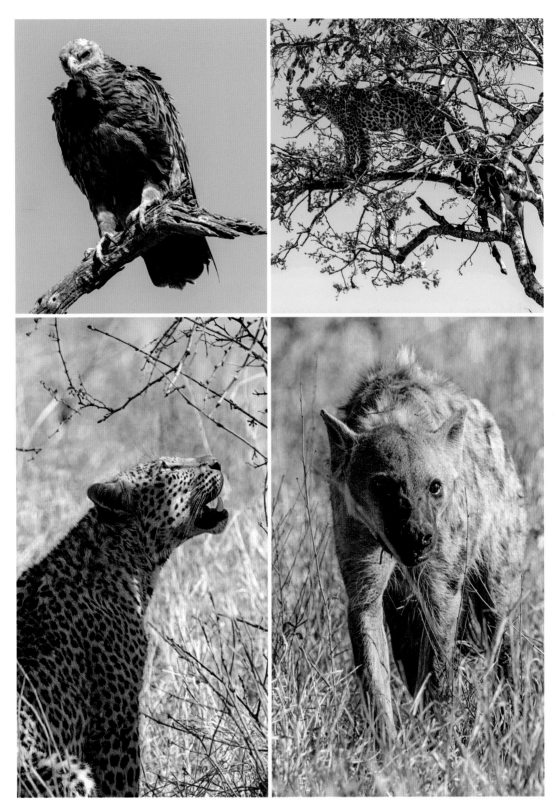

Join the Queue

ROLF WILLIG

Following the S137 back to our rest camp, Berg-en-Dal in Kruger Park, in the distance, we saw a tree with several big birds in it. Aware that this might indicate something interesting, we kept a close lookout. When we passed the bird-laden tree, I thought I glimpsed a shape lying under bushes on the left. "A lion cub," I said to my wife. In great excitement we reversed and saw, not a lion cub, but a well-camouflaged leopard in the shadows of the bushes. Our view wasn't great, and we waited in the hopes the leopard would move.

Eventually she did. There was nobody but us so we could be patient and take pictures whenever the leopard changed her position. We noticed she looked up into the tree from time to time and following her eyes we noticed her kill, an impala, high up in the tree. Would she climb the tree? Indeed, after a few more glances upwards, she finally raced up the tree and reached her kill in a flash. First, she walked towards the end of the branch – a thin branch relative to her weight – and checked the surroundings. It seemed like magic how secure she was, balancing on a swinging branch, no shakiness, no fear of heights, absolutely confident the branch would hold… we hoped. She occasionally snacked on the impala and then she made herself comfortable on the branch again.

Without warning she seemed alarmed, standing up and staring. We searched in the same direction, yet saw nothing: however, after some time, we spotted a brown back moving in the high grass. Eventually, a hyena approached stealthily. Right under the tree the hyena stopped and looked up at the kill while the leopard was looking down. We wondered what they were thinking. We also wondered whether branches ever break, causing a leopard to fall to the ground…

Viewing the collection of interested parties and the leopard's supreme ownership of the kill, we guessed that for now, the birds in the other tree would have to be patient until the leopard left. The hyena would be waiting a good long while.

As the Bones Shatter

LES BRIDGLAND

"It's time to move," I said to my wife. It was February 2017 and Tropical Cyclone Dineo was affecting the weather conditions in the Kruger National Park. We packed up our camping gear and headed north as the rains began to lash the southern part of the park. Our destination was Letaba Rest Camp in the middle of the park. It was there, just after crossing the Letaba River that we came across this beautiful specimen of a leopard in a tree about five metres from the side of the road. It was siesta time and that is how we came to spot him.

After a while, he decided it was time to eat some more of the impala kill he had in the tree. The leopard ate the bones of the impala leg and everything else he could manage, even trying to eat the hoof but that dropped out of his mouth. He looked just like a puppy that had lost its favourite toy as he peered into the undergrowth below the tree, trying to see where the hoof had fallen. To hear how the bones snapped and broke as his jaws crunched through sent shivers down our spines. We wondered what damage a leopard that size could inflict upon a person and what chance of survival there would be, or what defence one could put up.

With the time creeping towards 17:00 and knowing the gate to the camp was closing at 18:00, we wondered how much longer we could stay there with him. At just after 17:00, he descended and wandered off. But as we turned off towards Letaba Rest Camp, I predicted he would be there the next morning.

And so it was. True to form, we found him fast asleep again in the same spot. Patience wins the day when you are fortunate enough to be spending time with a wild animal in its natural habitat. In this case we waited almost two hours right in front of the tree as others drove by, only taking some quick pictures before they moved on.

When the leopard decided to move, it was merely to climb down to the fork in the tree, survey his surroundings and then be off. But those brief moments when he stood poised in the fork of the tree were our reward, resulting in some great photographs.

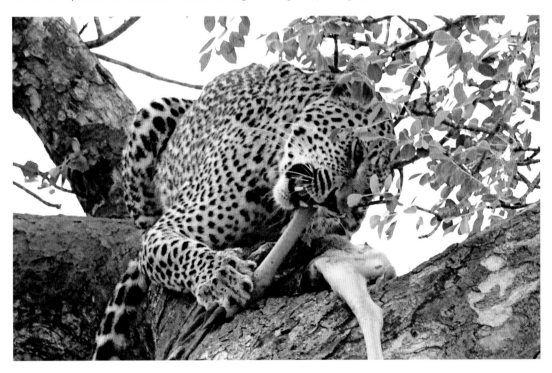

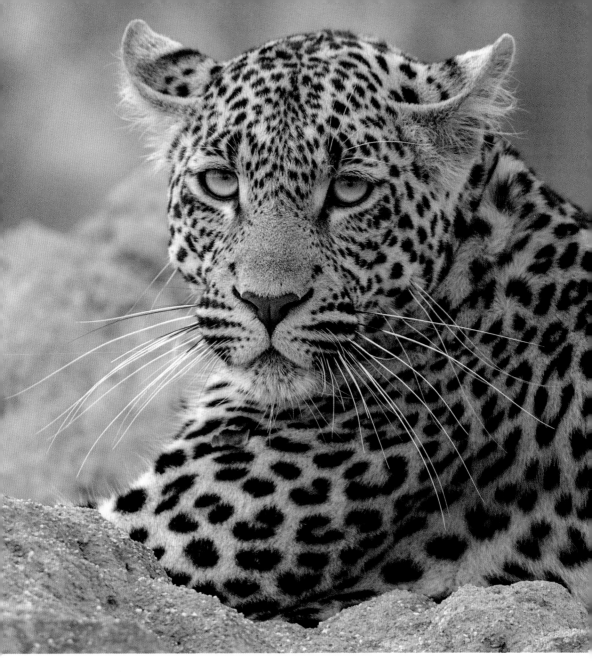

Princess of Djuma

LUCA NETO

I was fortunate to spend a weekend at Djuma Private Game Reserve in 2019. On an early-morning game drive, we spotted the leopard Tlalamba in a marula tree with her kill. We spent some time watching her enjoy her meal.

The following morning we returned to find her.

By this time, she had obviously had enough and was resting on a termite mound and this is where she remained for the rest of the day. She was quite happy to have us take numerous photos of her, knowing, I'm sure, that this was the price one pays for being royalty.

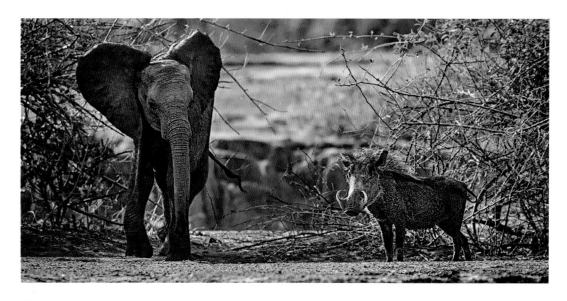

You've Got to Know When to Fold

KEVIN DOOLEY

A young elephant became detached from its herd when it decided to chase a warthog. Unbeknown to the elephant, two lions had also been following the warthog.

The pair saw an opportunity, changed course and took down the young elephant. But the racket the juvenile made enabled the herd to locate it fast and the other elephants charged the lions. The lions had to concede defeat and give up. One can only imagine the ticking-off the mother communicated to her young one as she helped it to its feet.

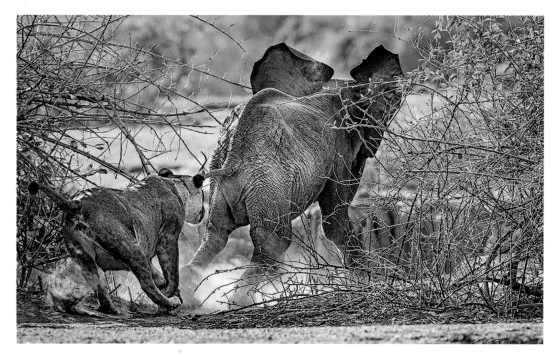

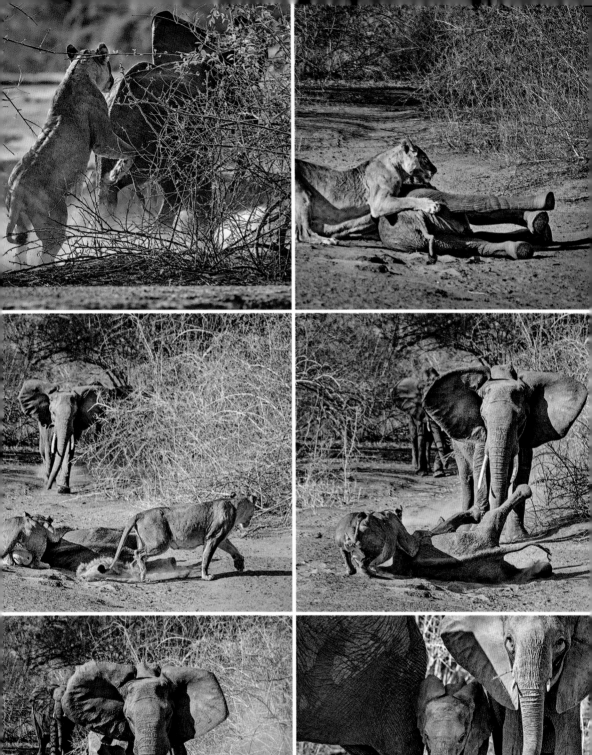

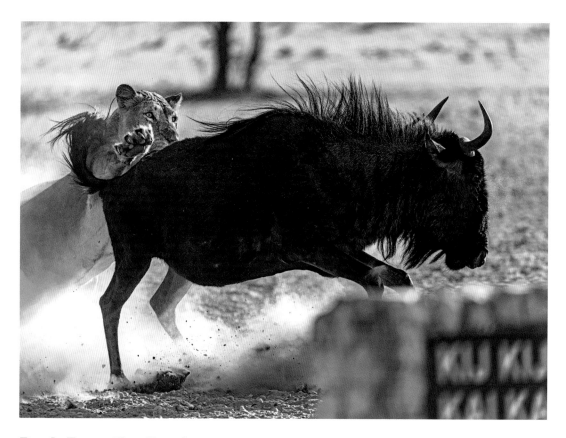

Back From the Dead

RUDI ZISTERER

In November 2019, I witnessed how a lioness killed the same wildebeest twice. Parked at Ki-jKij Waterhole in the Kgalagadi Transfrontier Park photographing jackals feeding on an eland carcass, I heard a strange sound and saw a lioness attacking a wildebeest right at the waterhole. "Dammit!" I thought, "I missed the kill!" I took a few pictures of the lioness who had already wrestled the wildebeest down. The wildebeest, to all appearances, took its last breath. The lioness suddenly stood up and ran, chasing the jackals away from an earlier kill of a wildebeest baby she had under a tree nearby. (I hadn't seen that kill, but noticed the carcass under the tree. I reckoned it was a day old.)

Then the wildebeest at the waterhole moved its legs. It startled me as I thought it was dead. The next second, the wildebeest was back on its feet. The lioness spotted and attacked the wildebeest

and this time I was fortunate enough to capture the whole process. In the end, the lioness killed the wildebeest by breaking its neck. Second time lucky for the lioness, no second chance for the wildebeest...

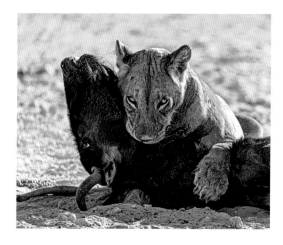

Lion Drama at Okondeka

HAMMAN PRINSLOO

Etosha National Park's Okondeka Waterhole is one of the best lion spots. During our December 2018 trip, we had multiple quality encounters with a big pride of lions. One afternoon, they were spread out around the waterhole.

Without warning, a female jumped out from the dunes behind the parking area of the waterhole and chased down a springbok. The rest of the pride noticed the commotion and approached the female who was catching her breath with the springbok in her jaws. When lions are hungry, they forget they are family and it's every lioness for herself. They tried to steal the carcass from the successful hunter. Every lion finally got a place at the dead animal, although the poor cubs had to climb over the adults to reach the carcass. Eventually all lions got a bite and their faces and paws were drenched in blood. Brutal, but survival of the fittest.

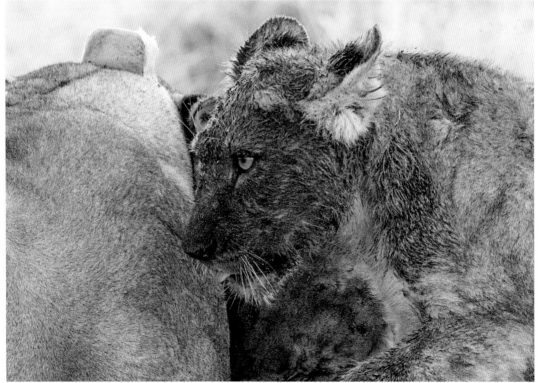

Power is a Kalahari Lion

KOOS FOURIE

While in the Kgalagadi Transfrontier Park in September 2019, we went to the KijKij Waterhole in the hope of good sightings. About three kilometres from the turn-off to the waterhole I caught sight of an imposing male lion. My attention was immediately drawn to the underside of his mane, which was covered in blood, as was his chin.

He lay, panting, next to a sizeable carcass. I stopped the vehicle and settled in behind my camera. Through the lens I recognised the carcass as that of an eland, Africa's largest antelope, weighing, on average 800 kg. A male lion, by contrast, weighs a mere 200 kg.

The morning felt fresh with a hint of the coming heat that would engulf the arid Kalahari. A few opportunistic jackals were hanging about, keeping a safe distance despite the lure of the lion's recent catch.

The early-morning sun accentuated the tawny colour of his fur. His imposing stature, combined with his ferocity and brute strength, demanded respect and awe.

Then, as if sensing my admiration, he lifted his head aristocratically and roared as if he wanted everybody to be aware of his royal presence. The resounding roar reverberated straight through my whole body, giving me goose bumps and sending shivers down my spine. He got up and sauntered towards the carcass. Those impressive canines sank into the eland's muscular neck, but instead of feeding, as I'd expected, the lion began to haul the carcass across the bone-dry sand southwards.

This made no sense as I could see no trees in the immediate vicinity. He dragged the eland carcass with relative ease but needed breaks every five to 10 metres. I realised then that he was aiming for a camelthorn tree which was a daunting 70 metres away.

The prospecting black-backed jackals followed him, skirmishing for the bits and pieces that fell off during the journey. Every morsel was snatched up and consumed hungrily. Resources are spread thinly in the Kgalagadi and you need to capitalise on every opportunity, especially if you are a scavenger.

Some 20 minutes later, the lion reached the tree and pulled the carcass into the inviting shade, and wearily but contentedly, settled next to it. It had been an exhausting journey, tugging that weight over such a distance.

As I drove away a little later, I knew the lion would stay and feed under that tree for the next few days. Breakfast, lunch and dinner – served!

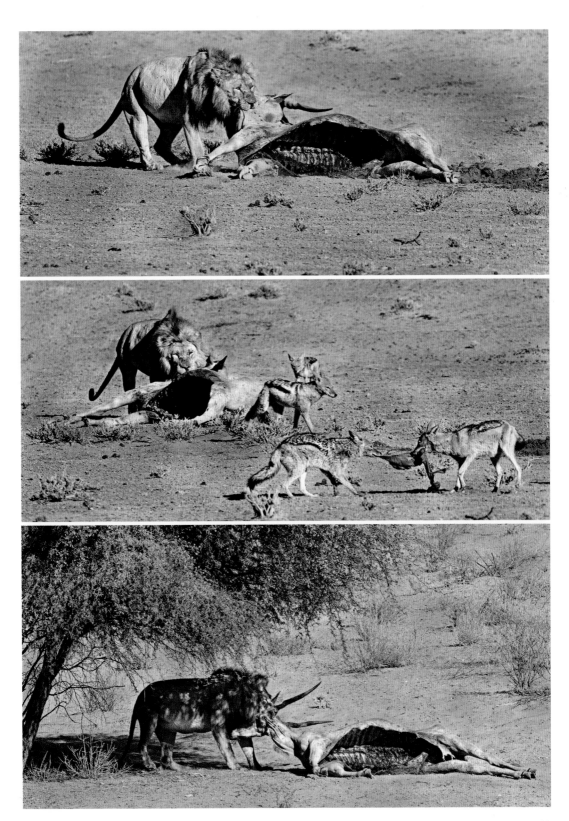

The Lions of Melkvlei

HAMMAN PRINSLOO

We're Kgalagadi regulars and have stopped at Melkvlei multiple times over the years for coffee, a bathroom break or just a leg stretch. This has (un)-fortunately often been interrupted by lions.

Once we arrived at our preferred picnic table in the morning to find it occupied by the local lion pride. We counted four lionesses just under the table! The rest of the pride was scattered all about and the pride male, appropriately, was taking a nap next to the men's bathroom.

The following year we arrived as the pride was drinking water from a puddle that had formed after the recent rain. All hell broke loose when the males teamed up to fight one of the other lions. Yes, all this happened at Melkvlei Picnic Site. Have a look around before you get out next time.

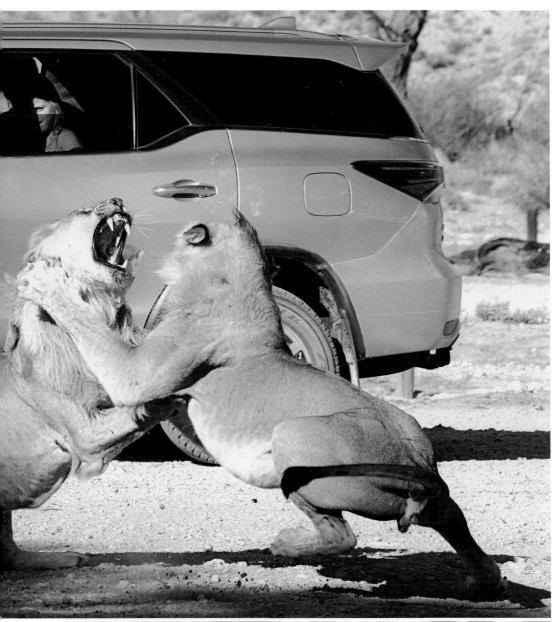

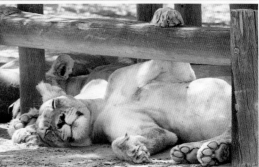

The Queen on Her Throne

AYESHA CANTOR

In the weeks leading up to our long-awaited trip to the Kgalagadi we had been following posts on Facebook regarding a young leopard that seemed to be struggling to survive on her own, possibly because she was too young.

Of course, we were hoping like mad to be lucky enough to spot her.

The day finally dawned: we had arrived and were making our way from Twee Rivieren to Mata Mata. The anticipation was palpable.

As we drew closer to the area where Masego, the young leopard, had been seen we were sitting forward in our seats, noses not far from the windscreen.

We crept along at a snail's pace, inspecting every *driedoring* copse, every "perfect leopard tree" and every rocky outcrop but there was not a spot to be seen.

By now hollow disappointment was taking over and the inner bargaining began: "If I could only see

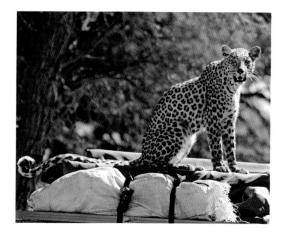

this leopard I would give up my wish to see 'XYZ'."

And then there she was, heading towards us with a mouse tail hanging out of her mouth. I don't think we quite believed our eyes; time stood still, it seemed but Masego kept coming!

Pandemonium ensued, we grabbed our cameras and released our held breaths as we glued our eyes onto this magnificent animal and her actions. We might as well have been invisible because she hardly glanced our way but walked towards a tree next to us. Then to our utter amazement she leapt up into the tree and onto the weaver's nest above us. It was hard not to shriek out loud as it seemed impossible that both she and the nest would not come tumbling down.

By now a few more cars had joined us and we all snapped away, enjoying every move she made which included jumping up onto the back of a bakkie and sniffing at the contents strapped on to the roof rack.

Some days later, we stopped at Dikbaardskolk Picnic Site en route to Nossob. We got chatting to fellow visitors who were on their way to Mata Mata from Polentswa. One of them named Wayne, could hardly contain his excitement thinking he had the sighting to beat all sightings to share with us – a leopard jumped up onto his vehicle!

My husband casually glanced over to his bakkie and said, "Oh yes, my wife got some awesome photos of that leopard on your van."

The expression on his face was priceless

Needless to say we exchanged emails and sent these images to him as soon as we were back home from our trip.

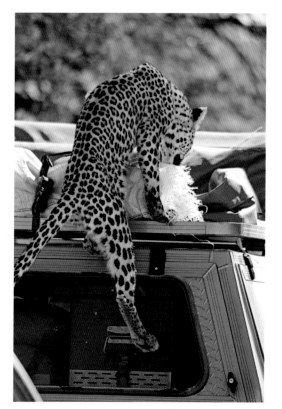

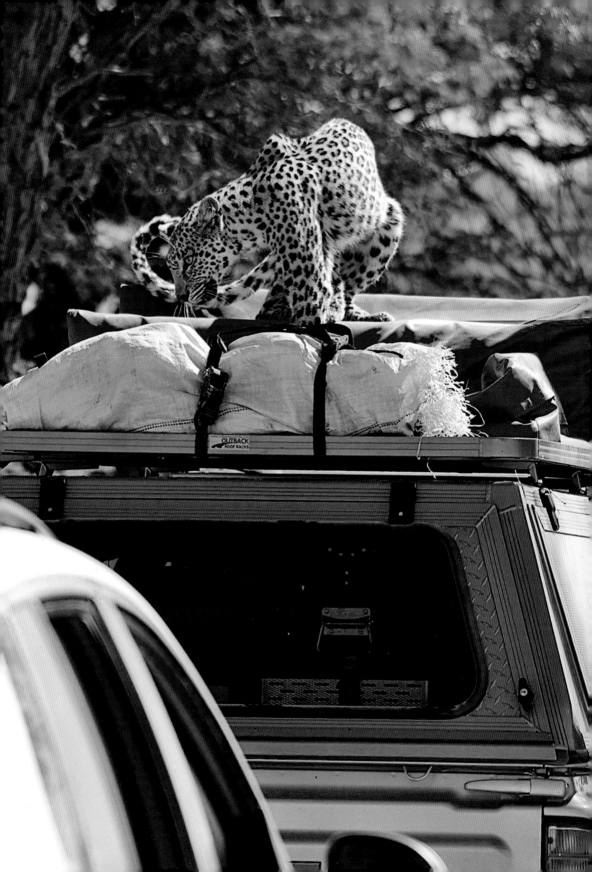

Leopard's Toy

SANDRA CLAYTON

We were on a photographic safari in the Sabi Sands, watching a young female leopard in the late afternoon. She was very playful, jumping on logs and rolling around. One of the photographers directly in front of me in the vehicle on the left, where the leopard was, dropped his beanbag over the side of the game vehicle by mistake. As the leopard was so close there was no chance of recovering it right away.

After a few minutes, curiosity got the better of the young female leopard and she came over to take a closer look. She began stalking but then sank to the ground and crawled closer. She stuck her paw out and patted the beanbag and then sniffed it. In an abrupt, quick move, she snatched it up in her teeth and ran into the thicket close by. We thought that was the end of the beanbag, but no… She took it up a tree and jumped from branch to branch with it but at that stage it was getting dark so we left her to it. There was nothing else we could do.

The next afternoon we went back to the area and to our amazement, she appeared out of the woodland carrying 'her' beanbag, treating it like a prize possession. She put the beanbag down under a tree and lay down close by. After some time, close to dusk, she decided to move off, presumably to hunt. As soon as she was out of sight, a tracker went in to retrieve the beanbag. Incredibly, it was still intact albeit with a few teeth marks!

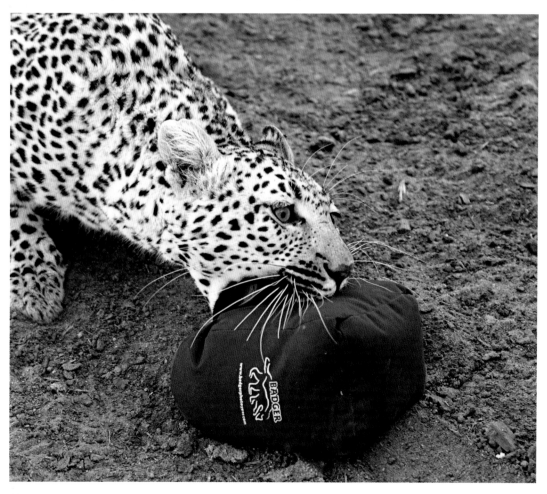

Here's to you, Max!

ELMAR VENTER

An eerie, sickening feeling surfaced as I stood by while the vet ended the painful misery of my best friend Max, my cocker spaniel. Tear-filled days with memories of him all over my house followed. Two weeks after that dreadful day, still lost in a sea of sadness, I was flicking through social media and saw that a pride of lions had killed a buffalo in the Kruger National Park, close to Satara Rest Camp.

Phoning my father for a chat, I mentioned the sighting. "Let's go!" he said. There followed a frenzy of packing, picking up my parents and driving from Pretoria to the park. The closest accommodation to the sighting we could get was at Olifants Rest Camp but I decided to enter the park via the Kruger Gate, closest to Pretoria, and stop at Skukuza Rest Camp to ask again for accommodation at Satara. By the time we arrived, it was unlikely that we could cover the distance to Olifants before gate closing time. The receptionist looked on the system – nothing available at Satara. "Phone them," I pleaded. Looking doubtful, she obliged. We were in luck; no accommodation available, but the camp manager offered us a unit under renovation.

The next morning we headed directly to the lion kill site. Would the previous day's frantic dash allow us to see the lions at their buffalo kill? My hopeful vision of a large pride of lions munching away was confounded by a skull and a few ribs. It was time to regroup and make the most of our short visit. We chose the S39 Timbavati River Route. We like to stop other cars to ask what people have seen. "Not much on this road," one driver noted. "Just a half-eaten impala in a tree, about to become biltong." At the tree, other drivers told us they had been waiting since early morning hoping to see the leopard, but no luck. We joined the few remaining hopefuls for the off-chance that the leopard would return in daylight for what was left of the carcass. As the morning wore on, the heat became unbearable. At times, we started our vehicle briefly for the temporary relief of a blast of air-conditioning. We became restless. As most of the other vehicles left, we set a cut-off: noon, which was 35 minutes away. With every humid minute ticking away, I became more and more doubtful that we would see the leopard. At three minutes to noon, sweltering, as we discussed leaving, the most magnificent male leopard stepped onto the road, jumped into the tree and finished off the remainder of his kill.

Sometimes it is worth taking an unplanned risk and following your gut. Patience is a virtue and is often rewarded. Sometimes you don't get what you want, but who knows what else is in store? Nature can nurture. But most of all, this experience remains as a kind of gift in memory of my best friend. Here's to you, Max!

A Bonsella

HANNES ROSSOUW

On my way back to Nossob's northern gate after my morning drive, I spotted this black-chested snake eagle in a tree. I thought I might get a decent take-off shot, so decided to hang around for a while.

Almost immediately after I had stopped, I got my take-off but much to my surprise, the eagle landed and caught, killed and consumed its snake-prey right next to my vehicle. The whole thing was over in a few seconds but I was really pleased with how it all turned out... I even got a second take-off shot as a bonus!

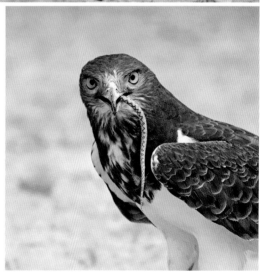

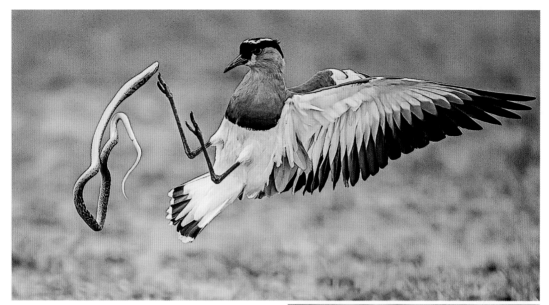

Retaliation

JOHAN CROUKAMP

We were watching two giraffes head-butting when I saw something white moving about 50 metres ahead on the R114 close to Renosterkoppie Dam in the Kruger Park.

On moving closer, we saw it was two lapwings tossing an egg-eater snake about. We assumed the lapwings were trying to get it to move away from their nest or perhaps kill it. They were scooping it up and letting it fall but at the same time trying to stay clear of any attempted strikes from the snake. These actions gave me the opportunity to snatch these magic shots of the lapwings with their wings fully open, forming beautifully composed pictures.

We sat for about an hour while this process of biting and tossing continued. The swooping movements must have covered an area of about 20 square metres.

Later I realised that the egg-eater must have swallowed one of the eggs. Perhaps the lapwings were trying to get the snake to regurgitate the egg. Or maybe this was their form of revenge – 'an eye for an eye'.

Unluckily for us, it was almost gate-closing time and we had to leave, so we didn't witness the final outcome. I suspect it would have been a fight to the death.

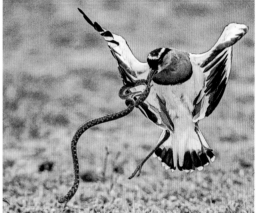

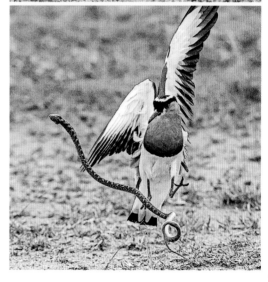

Sometimes it's the Quiet Ones...

HANNES ROSSOUW

It was at Rooiputs in the Kgalagadi that I encountered this scene.

A springbok lamb had been killed by cheetahs (I hadn't witnessed the kill but had been told by other visitors) and various birds were trying to get their share of the spoils. I was surprised to find that it was a black-headed heron that dominated the scene, keeping the tawny eagles and the pale chanting goshawks at bay. It even fended off a few vultures when they arrived at the kill.

At the same time, there was another dimension to the battle for supremacy because the pale chanting goshawks were attacking the tawny eagles from above. Eventually there were too many vultures and the heron had to concede defeat.

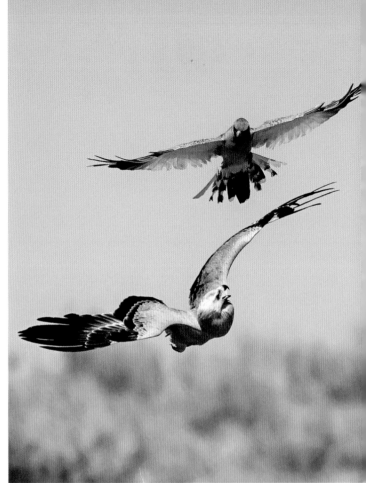

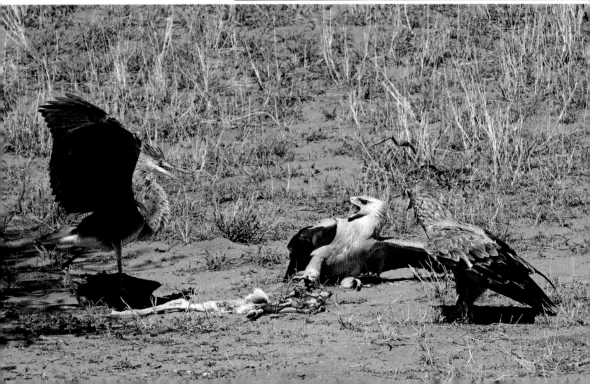

The Most Relaxed Rock Kestrel Ever

CALLUM EVANS

On a recent birding trip to Velddrif to spot the vagrant Wilson's phalarope, we came across a rock kestrel perched on top of a rat it had just killed, right by the jeep track. The rat was nearly the same size as the kestrel and probably weighed more than it, too. When we stopped the car to photograph it, we were afraid it would fly off immediately. Instead, it began to feed on its kill, starting with the head. Keeping my eye on it, I carefully got out of the other side of the car to try and photograph it at ground level, using the rear of the car as cover. Somehow it worked, and I and a few others were soon lying flat on the road, photographing this kestrel as it fed on its kill. The bird was completely unfazed by our presence, barely two metres from it. We did our best not to disturb it by keeping low to the ground and not making unexpected movements. I was able to observe the feeding process, as it worked its way down from the head to the chest and the stomach cavity. Pieces too big to swallow were shifted aside for later.

In a relatively short time, over half the rat was gone. By the time we moved on, we'd been with this bird for over 30 minutes, photographing it from four different angles and it barely acknowledged our presence.

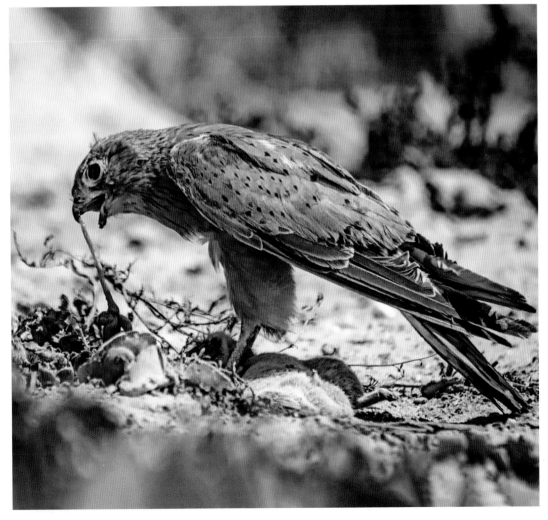

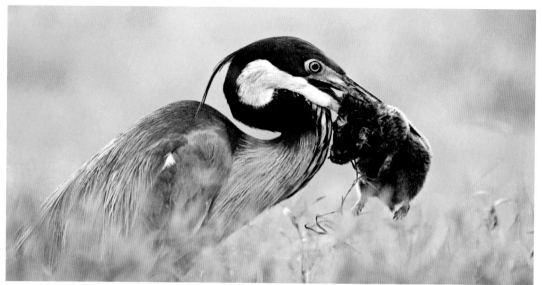

It's Not Like a Trip to the Supermarket

ROLF WIESLER

As an amateur photographer I try never to leave my camera at home as you never know what might happen...

While we were driving up the sand road to enjoy the view from Rhodes Memorial in Cape Town, we saw a black-headed heron standing in the grasslands on the side of the road. We stopped to look at it and noticed that it had something large in its bill. After retrieving our binoculars and camera we established that it was a hefty rodent which looked much too big to be a prey item for the bird.

We watched the heron for over 20 minutes. During this time, the heron, in-between making attempts to swallow it, smashed the rodent on the ground, maybe to try to make it more pliable. Eventually the heron did manage to consume it by swallowing it whole.

After downloading the photographs we identified the rodent as a mole rat. Even after our research on the black-headed heron made it clear they consume a diverse range of small mammals, birds, reptiles and invertebrates, it was still mind-boggling that it could swallow such a large item. It highlighted what hard work goes into obtaining food. The struggle to stay alive in the wild is just that – a struggle.

Ghosts of Table Mountain

CALLUM EVANS

For me, the Table Mountain ghost frog had always been an enigma, a creature so rare and elusive that it is only ever spotted at night in several gorges on the eastern slopes of Table Mountain. I never believed I'd get the chance to see them for myself but then at the beginning of February

2020, a friend told me about a new population of ghost frogs that had recently been found on the mountain and invited me to join him in looking for them that night. I met him and a friend at 21:00 and we hiked up the ravine where the frogs had been seen.

Reaching the top, we examined the wetter sections and after some searching, our patience was rewarded when we found six different ghost frogs, along with a western leopard toad (rarely seen at any kind of altitude). They were a lot bigger than I thought they'd be, and beautiful, with mossy-green skin covered in purple spots. I never imagined I would see one ghost frog in my life, let alone six! And what was even more amazing was that this population was entirely new to science: nobody had known these particular individuals existed until a couple of months before.

While it's true that hiking up the mountain at night was mildly unnerving, it was an incredible experience to observe these endangered frogs in a dark forest and one I won't forget in a hurry.

The Path to Co-existence

TOM PRINS

I view myself fortunate in that my property is at the centre of the daily route of a troop of vervet monkeys when they go in search of food. They visit our place twice daily. We treat them with respect, refrain from feeding them, but make sure that sufficient water is always accessible. They need water on a daily basis.

These monkeys move in groups of between 10 to 50, following a fixed route. This is retained in their collective memory, so generation after generation has used it. Unfortunately, people have built houses in their path, disturbing this traditional route; an example of how we humans fail to show proper homage to nature's way.

When we open ourselves to learn from nature, we discover so much. These are some of the discoveries we have made:

- Vervet monkeys will attack dogs and humans only when provoked.

- People should avoid direct eye contact because the monkeys might interpret this as aggression.

- When walking past them, don't make sudden movements.

- They can distinguish colour and this helps them to identify different fruit and edible flowers.

- They maintain a strong hierarchical system with regard to feeding, friendship and controlled fighting.

They are also curious. I'd be sitting outside with my laptop, minding my own business, and they would slowly approach me, coming as close as two metres.

I thought I'd experiment. I set up an old redundant camera and tripod as a fixture in the garden, covering it up at night and when it rained.

At first, they merely looked at the set-up from a distance as they were drinking. But as the days passed, they became more interested and familiar with it, to the point when curiosity took over. I think they may have spotted a reflection in the lens and this prompted them to start fiddling with the camera. On occasion, they stared at me as if they were waiting for me to supply either some film or some training.

When the adults (mostly male) were involved with the camera, the females and minors were relaxing in the garden or grooming each other.

The combination of strong discipline and playful curiosity won my admiration and affection. It reminded me that when we humans treat them with respect, monkeys will tolerate us and be prepared to co-exist peacefully.

The Crowned Eagle Homemaker

BURKHARD SCHLOSSER

On the morning of 26 October 2019, while I was out in the suburb of Montrose, Pietermaritzburg, thinking I might get a chance to photograph a crowned eaglet which was nesting there, I noticed one of its parents moving in a eucalyptus tree. I couldn't make out what was happening in the tree. In the hopes of capturing something interesting, I clicked away with each movement. And then, to my satisfaction, the bird came out into the open and flew towards its nest carrying a large broken twig it had taken from the giant tree, giving me the chance to capture these images.

It was a wonderful experience to have witnessed this large raptor in action. The eagles have been breeding in this area for many years now. My first experience documenting these birds was in 2012–2013 for a period of 18 months. Seeing and photographing this large raptor on this occasion was a wonderful addition to my memories and photo collection.

Up for the Challenge

BURKHARD SCHLOSSER

I went out in January 2020 to a nesting site of crowned eagles and their eaglet in the Town Bush Valley area of Pietermaritzburg. The mother of the eaglet had brought her prey to the nest just before I arrived and the two were having a great feast. I wasn't able to identify the prey from what I saw or captured on camera.

I was startled to see the mother bird pass along a bone – which I judged was far too large – to her chick. The eaglet struggled to swallow this enormous bone but eventually got it down. The concerned look from the mother tells the story! A memorable sighting indeed.

Close Encounters

ROLF WIESLER

While out birding with a friend, Kevin du Plessis, at Marievale Bird Sanctuary, we had a close encounter with a spotted-necked otter. One of the roads within the sanctuary splits between a high-level and low-level bridge and it was while driving along the bottom section that we saw movement beneath the high-level section. Thinking it was a waterbird, we got out of the vehicle to get a better view but soon realised that it was an otter swimming under the bridge.

As it was fairly close Kevin changed to a 'smaller' lens, and lay on the road to get a better view and some pictures. At this point the otter became curious and leaving the water, moved slowly along the road towards Kevin. Kevin had no intention of frightening the otter so kept very still and concentrated on taking his photographs. Eventually the otter was so close that it actually touched the camera and there is even a nose-print on the camera's lens to prove it. The whole interaction lasted about five minutes before the otter got bored and returned to the water and swam away.

This 'meeting' remains one of Kevin's best 'birding' experiences despite having nothing to do with birds!

Leopard in Training

MATTHEW SCHURCH

We had been up at Grootkolk in the Kgalagadi Transfrontier Park for two days and sightings had been scarce, but one evening we heard that a leopard feeding on a kill had been seen south of the camp.

The next day we went to the site. Close to the road, half-hidden behind a fallen tree, we spotted a leopard cleaning his paws. I identified the leopard as the 16-month-old cub Tebogo. He ambled off in a southerly direction.

A hyena was walking on the other side of the riverbed with, possibly, a springbok leg in his mouth. Tebogo's curiosity led him to approach the hyena. He got within 50 metres and crouched down but the hyena picked up his scent and charged. Tebogo quickly dashed to the nearest tree.

The hyena walked past the tree where the kill was stashed. Would he steal it? But he passed it, instead crossing the riverbed once again. He reached the top of the dune and started sniffing around, which led us to spot another leopard in the tree! We identified her as Safran, Tebogo's mother, from the pattern of rosettes on the left back leg and side. She wasn't happy about the hyena being there.

Tebogo hadn't learnt his lesson and approached the hyena again, but was chased up a small tree and for the next 10 minutes, the hyena stood guard. During that time Safran slid away. After the hyena lost interest and wandered off, Tebogo came down and rested in the shade, melding into the dappled shadows.

After a stop at Lijersdraai we went back and saw there was a second untouched kill in another tree. We couldn't see any of the leopards but we opted to come back.

At 16:00 we headed south again. We stopped at the stored kills and heard the rasping call of a leopard. Then we saw one walking right towards us. It was Tebogo, with his unique wide circle of light fur round a small rosette on his left shoulder.

He paused under the second kill but it seemed he was satiated. He went towards the riverbed, perhaps to drink. But he was heading towards Safran, lying in clear daylight in the centre of the riverbed.

We hadn't seen her but it was her call we'd heard. She looked exactly like a termite mound.

As we watched, Tebogo quickened his pace and launched himself at his mother. They started to fight. There was a flurry of tails and paws, a pause, and Tebogo would attack again. We could see this was play-fighting, but also essential training for the youngster.

Tebogo was already larger than his mother and he would soon have to leave her. He'd need to learn to defend himself against the other bigger males in the area that are experienced fighters. Now, with Safran, he reared up and she ducked and cowered. On one occasion Tebogo took it a bit far and Safran had to chastise him! They repeated this practice-fight about five or six times before becoming too hot and tired. Safran eventually called an end to play-time.

They walked to the first kill and snacked on it and Tebogo took the opportunity to use the shade of our car for a lie-down. Perhaps the ample food and water gave them the energy for the mock-fights. We had to leave but knew the second kill was still untouched and planned to come back.

In the morning we found the second kill had been devoured overnight. Lying there was the large dominant male in the area, N!xau, but he soon sloped off. Later we spotted Safran walking up the road. She climbed the tree and fed on the kill. But when N!xau appeared, Safran ran away. He munched on the carcass, until he was disturbed. Late in the afternoon we saw Tebogo walking in the road. He too climbed the tree and ate before having a long drink from the river. We'd seen three leopards in the same day all feeding off the same kill!

I suspect that N!xau is the father of Tebogo and that he's probably angling for him to leave his mother so that she'll come back into heat. Tebogo – beware…

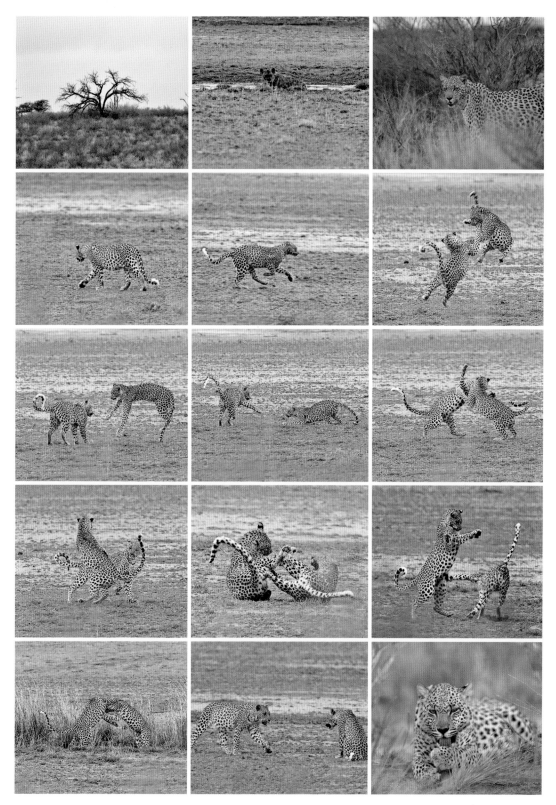

Battle of the Bulls

DEREK WHALLEY

While we were staying at Simbavati Lodge on the banks of the Timbavati, we were awakened around 3:00 with a commotion in the river.

When dawn came, it illuminated a territorial battle between two hippo bulls. This fight had already been going on for about three hours and was to continue for another two until the smaller of the bulls gave up. He moved to a sandbank downstream where he lay all day, not daring to go back into the water despite the lacerations and tusk stabs he had endured.

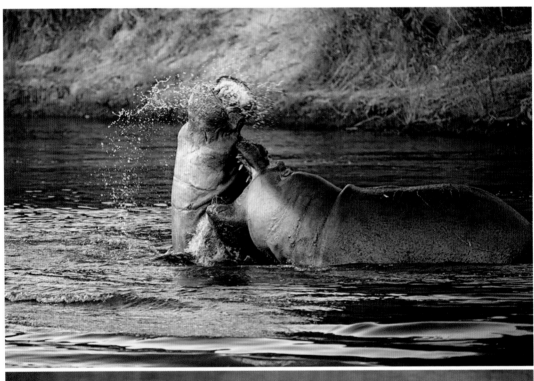

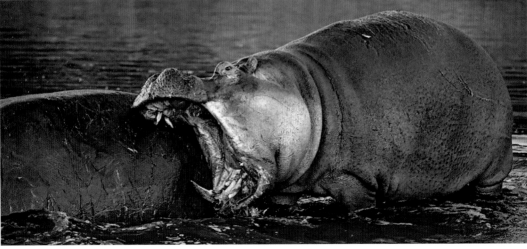

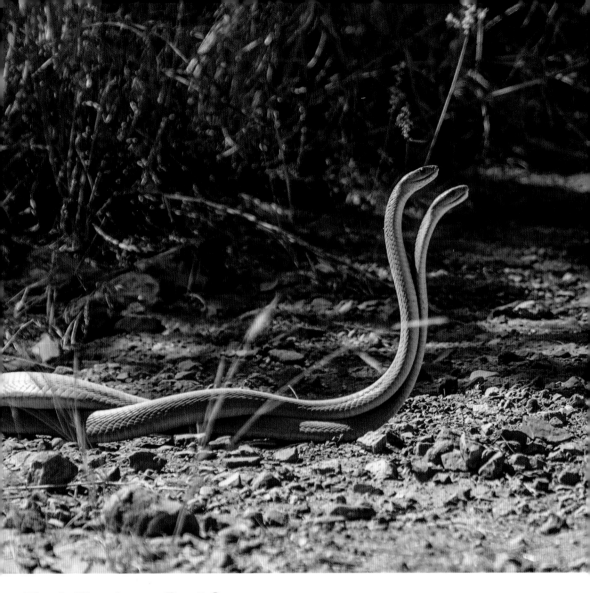

Black Mambas – Bout One

SHARIFA JINNAH

The black mamba is the second longest venomous snake in the world after the king cobra. It is also claimed to be the fastest snake, as it can move about 15 km/h.

It is often said to be the deadliest snake in the world and with good reason. It is a large and active snake that advances quickly, with a motion that lifts as much as a third of its body off the ground at a time. The largest one accurately measured in the past 30 years was 3.8 m.

Rival males wrestle each other for supremacy.

Opponents attempt to subdue one another by intertwining their bodies with that of their rival and wrestling with their necks. Some observers have mistaken this for courtship. The weaker snake will tire or get pinned down by the stronger one.

We had this remarkable sighting of two males in combat at Loskop Dam Nature Reserve. They did battle for eight minutes on the road before slithering away in the bush. They seemed evenly matched. Would they confront each other again, I wondered?

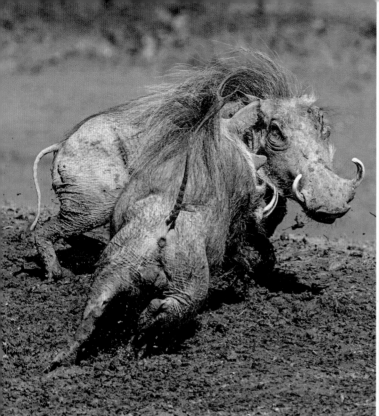
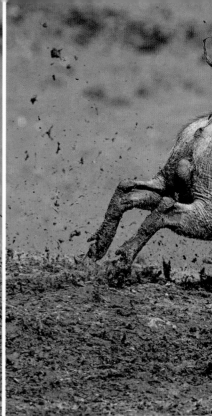

The Two Sides of the Equation

JEAN DU PLESSIS

While visiting the Addo Elephant Park, I had so many pleasurable sightings that I am quite unable to single out just one. It was often the 'little moments', rather than a dramatic kill, for example, that delighted me and got my camera working hard. There are a couple in particular that stand out, showing the two sides of survival in the wild.

One experience was observing a marsh terrapin sitting on a rock at Hapoor Waterhole, absorbing the heat of the sun. It was a female and she was not alone for long because she was soon joined by a male terrapin who rather fancied her and I was able to capture their mating.

The other was at Marion Baree Waterhole, where a warthog, drinking its fill, was interrupted by the approach of another warthog. The first one's reaction was to defend what it saw as its own space and it turned ferociously and sent the other one packing.

Placing these events next to each other led me to thinking about the two essential aspects of the continuation of any species: the opportunity to reproduce and the necessity to defend resources. And there it was, caught by my camera. Love and war, if you like...

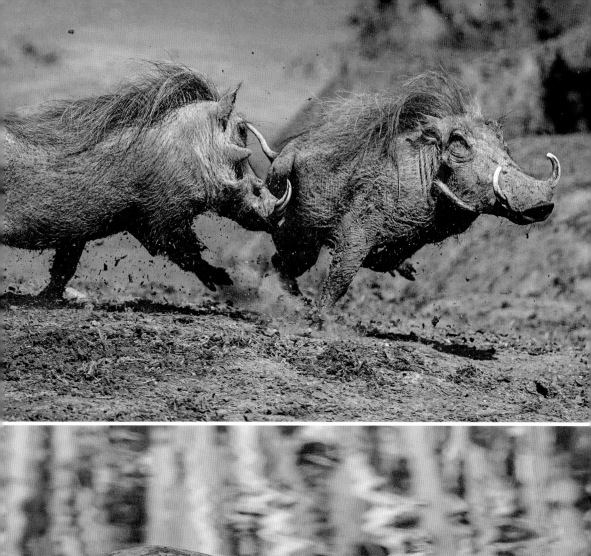

Try a New Technique!

GERHARD GELDENHUYS

I captured these images at Sunset Dam in the Kruger National Park. Sunset Dam is one of our favourite spots and we've spent many happy hours there.

A hamerkop, with its distinctive head-shape, caught our eye. We observed this bird flying over the water. We are more used to seeing the hamerkop wading in the shallows, delicately catching insects, amphibians or small fish. But this one took an innovative approach.

It skimmed over the water (with its quota of crocodiles, also on the lookout for fish) and snatched up a fish on its flight, returning to the water's edge with its prize proudly held in its bill.

This unusual hunting technique was not flawless, I admit, but netted the hamerkop enough prey to make it a successful strategy. Break-out behaviour wins the day!

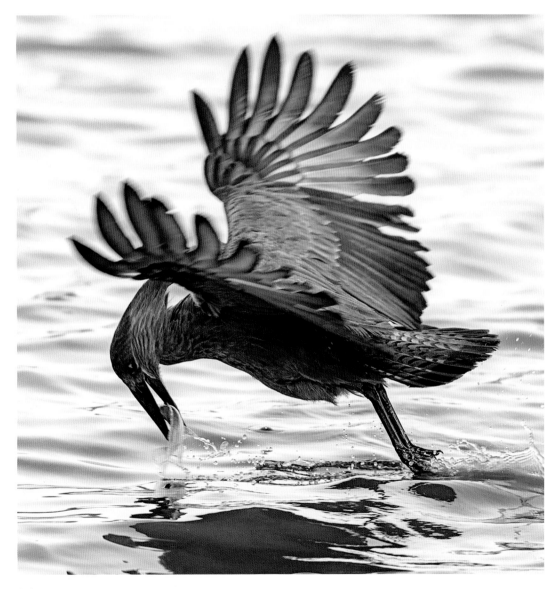

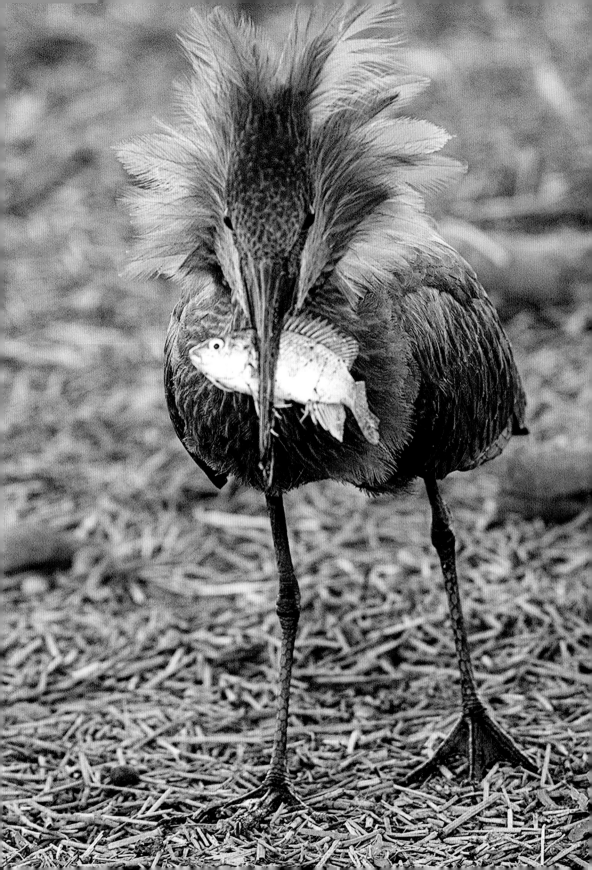

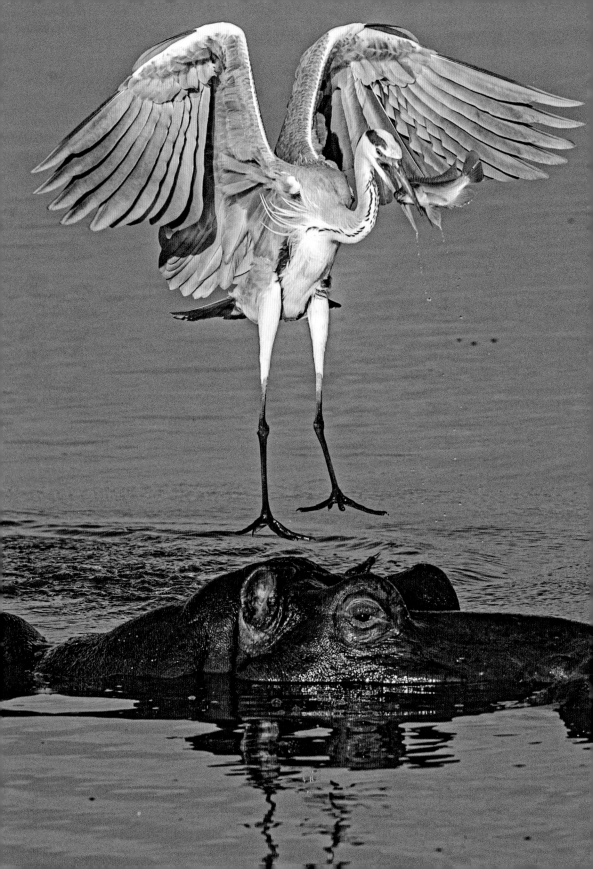

Coming in to Land

GERHARD GELDENHUYS

Like many other photographers and visitors, I spend hours at Sunset Dam in the Kruger National Park which provides me with marvellous opportunities to examine the behaviour of various bird species and observe their respective hunting techniques. The challenge is trying to anticipate the bird's next move, and it's a challenge I do my best to meet. Together with full concentration and lots of patience, this close attention can deliver great eye-catching pictures.

Even on a slow day, I stick it out and sometimes I'm rewarded, as I was when I managed to snap this grey heron. The heron took the opportunity to turn the broad, comfortable length of the hippo's back into a landing strip and I couldn't help but smile at this example of entertaining interaction between two such different species.

Next time you're about to pass Sunset Dam, I suggest you stop and give yourself the chance of an interesting sighting.

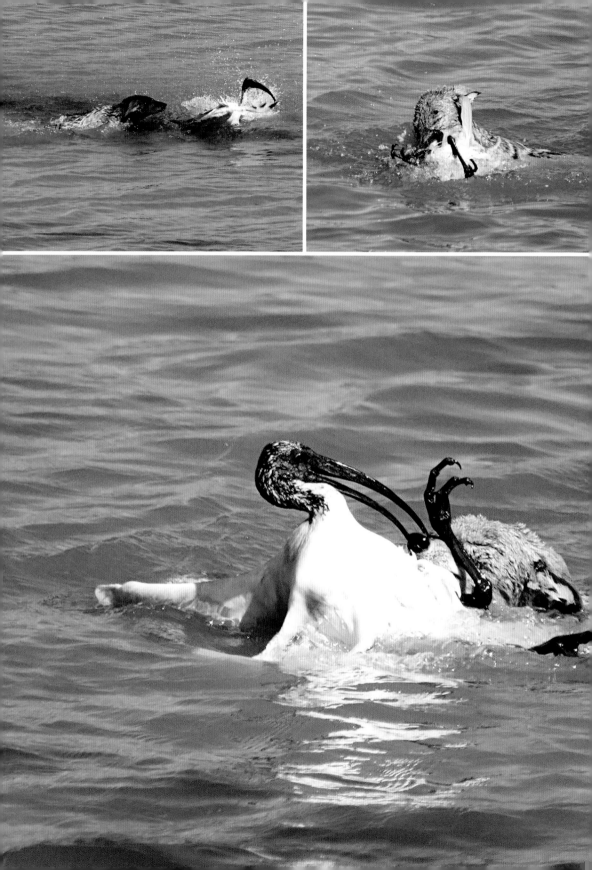

Jackal Kill at Lengau Dam

RONALD VAN DEN HOECK

The Lengau Dam in the Pilanesberg felt peaceful and harmonious. Three hippos were relaxing on the shore when a big elephant bull approached them and chose their place as his drinking spot. The hippos, naturally, became nervous. I had taken a position at the viewpoint in front of the dead tree in the water, full of white-breasted cormorants and African sacred ibises. Then, on the other side of the dam, we spotted a couple of black-backed jackals with two half-grown pups. One jackal looked intently in our direction and then sprinted off, passing and ignoring the hippos and the elephant. The jackal was so fixed and determined that it clearly had a plan. We lost sight of it as it disappeared behind us.

On the bank of the Lengau Dam was a large colony of African sacred ibises. There was instant panic and the colony took off towards the dead tree. Some birds chose the water for a safe place. This gave the jackal the chance it was looking for and it jumped in and swam rapidly towards one of the ibises. The ibis tried to escape but couldn't get out of the water in time: the hunter struck, grabbed the ibis and swam back to the side. The ibis fought for its life, pecking at the jackal's snout and kicking wildly, but the jackal had too firm a hold. The bird's chance of surviving shrank to zero as it was submerged.

The jackal crawled out of the water while the ibis was in its last convulsions. Everything took place a few metres from us and in a few seconds. Meanwhile the other jackal and the two pups arrived. The hunter disappeared into the tall grass with its prey where the family lunch could take place. A half an hour later some white and black feathers were the only evidence remaining of another minor but essential drama of the bush.

Clash at the Waterhole

CAROL POLICH

Each morning I drove to the waterhole not far from Namutoni Camp in Etosha National Park, Namibia, in the hopes of seeing something interesting. Morning after morning, a lone jackal would stealthily approach when there were no other mammals to be seen. Only the unsuspecting doves gathered at the water's edge to drink, bathe and coo in the morning light. After three consecutive mornings, I realised this spot was where the jackal got his main meal. He proved himself a successful hunter as the doves misjudged the speed of the carnivore and the distance between them. Quick as a flash, on this particular morning the canine seized and tore apart a fluttering bird. All that remained were feathers in the dust. The jackal proceeded to trot around the waterhole, acting like the lord of all he surveyed, but missing no opportunity to pounce on more unwary doves which were instantly gulped down.

Neither the jackal nor I was aware of an approaching intruder until mayhem erupted. With arched back, extended neck and a powerful lunge, a second jackal attacked my main character. A fierce fight, complete with snarls, ferocious teeth and snapping jaws, scattered dust and doves. Once the air had cleared and dust settled, the canines separated, with the intruder slinking away, deferring, for the moment, to the dominant jackal. I'd been served more than I expected for breakfast that morning.

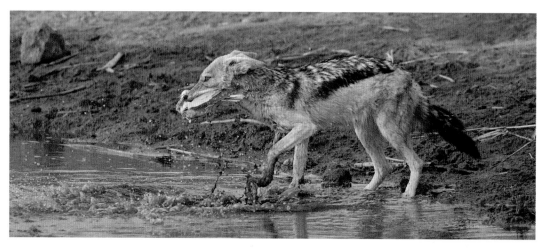

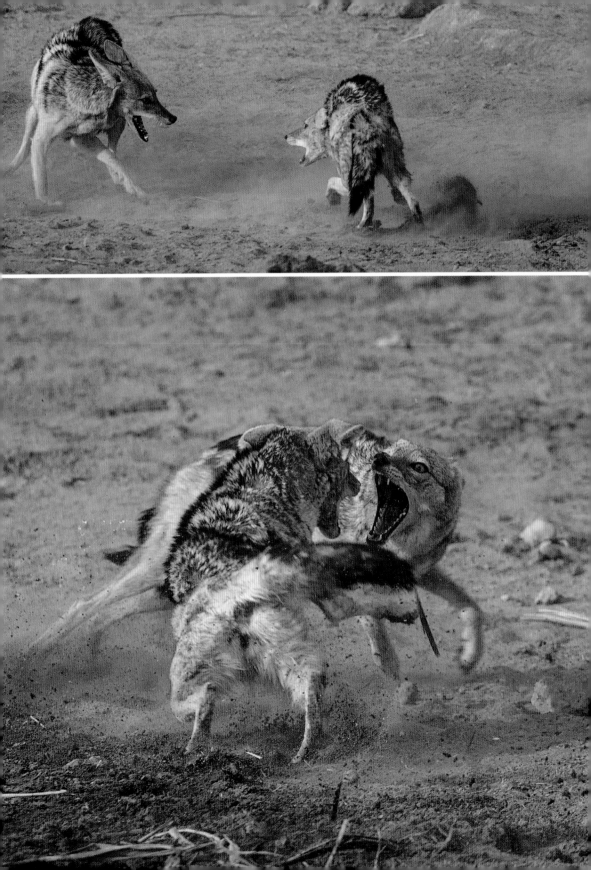

Adam Kotze

Brian Stratton

Darryl Jacobs

Eduardo Del Álamo

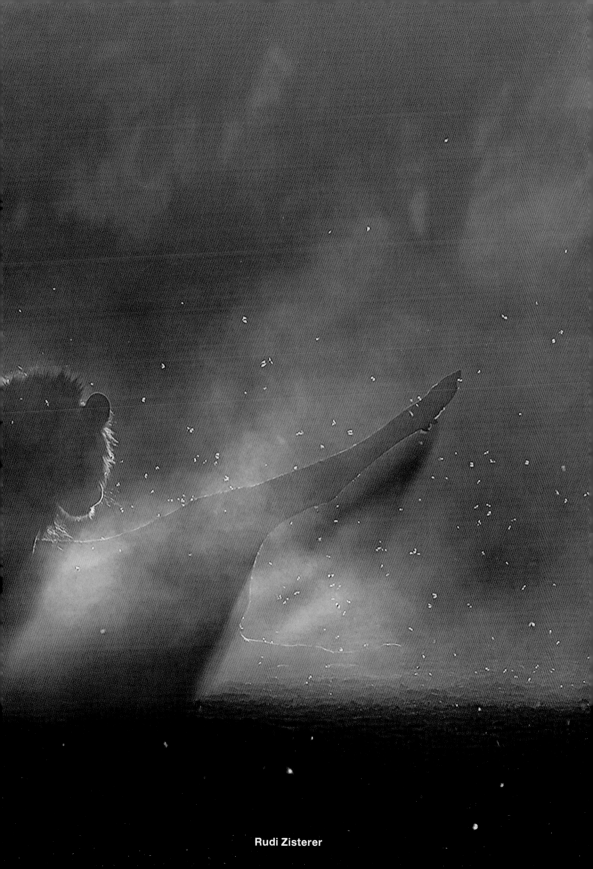

Rudi Zisterer

Ronald Lake

HPH
Publishing

Copyright © 2021 by **HPH Publishing**
First Edition
ISBN: 978-0-6398318-8-6
Text by various writers
Photography by various photographers
Compiled by Heinrich, Philip and Ingrid van den Berg
and Ronél Bouwer
Publisher: Heinrich van den Berg
Edited by Diane Mullen
Project management by Ronél Bouwer
Proofread by Ronél Bouwer and Margy Beves-Gibson
Design, typesetting and reproduction by
Heinrich van den Berg and Nicky Wenhold
Printed and bound in China

First edition, first impression 2019
Published by **HPH Publishing**
50A Sixth Street, Linden, Johannesburg, 2195, South Africa
www.hphpublishing.co.za
info@hphpublishing.co.za